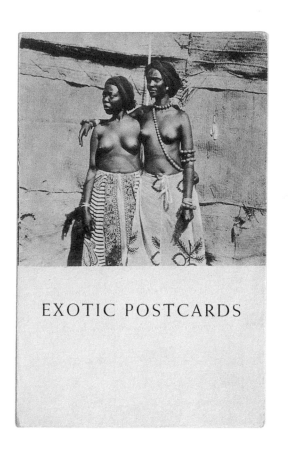

EXOTIC POSTCARDS

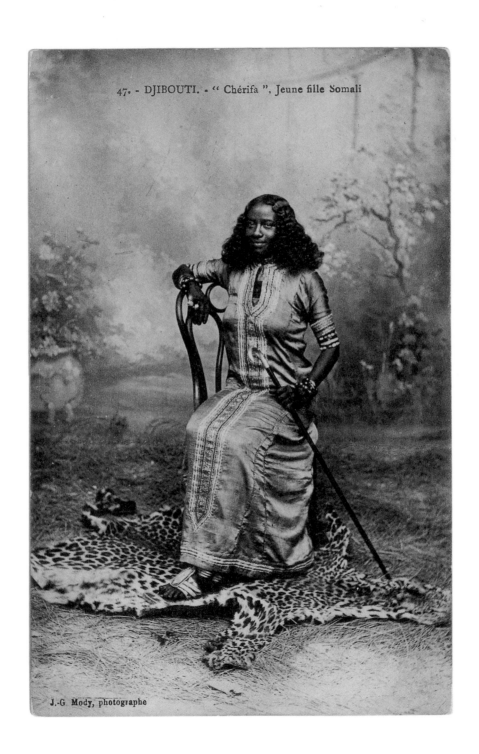

47. - DJIBOUTI. - " Chérifa ", Jeune fille Somali

J.-G. Mody, photographe

ALAN BEUKERS • INTRODUCTION BY PAUL THEROUX

EXOTIC POSTCARDS

The Lure of Distant Lands

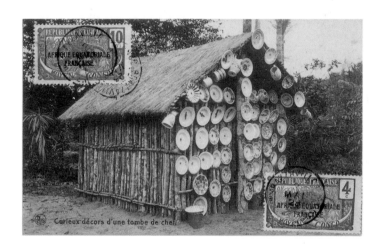

Curieux décors d'une tombe de chef.

with 200 color illustrations

Thames & Hudson

First published in 2007 in hardcover
in the United States of America
by Thames & Hudson Inc.,
500 Fifth Avenue,
New York, New York 10110

thamesandhudsonusa.com

Library of Congress Catalog Card
Number 2006908248

ISBN 978-0-500-54336-8

Printed and bound in Singapore by
CS Graphics Pte Ltd

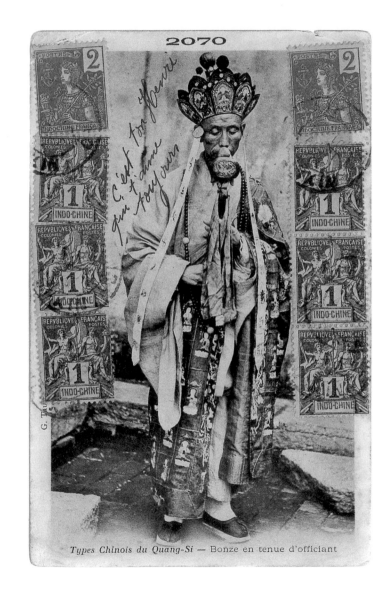

Types Chinois du Quang-Si — Bonze en tenue d'officiant

CONTENTS

INTRODUCTION

We are bewitched by visions of the faraway and the fantastic, because dreams of these Edens, of the overseas worlds of beauty and oddness and pleasure, seem to make life bearable. So our fantasies are sustained by a murmuring imagery of yearning. In this ironic reversal, home is no fun; it is either monotonous in its familiarity or else sad. Nor can anyone belittle the exotic as fiction. We know it's real, because travelers have brought back detailed witness of its existence. Travel provides proof of the exotic, which represents a kind of happiness and hope.

Shakespeare, an avid reader and cannibalizer of travelers' tales, was able to make Othello sound convincing when he spoke of his experience of exoticism, the wonders he has seen – "The anthropophagi, And men whose heads do grow beneath their shoulders." Eyewitness accounts and distorted versions of the wider world abounded in the 16th and 17th centuries, Richard Hakluyt's *Divers Voyages Touching the Discoverie of America* (1582) and Richard Eden's *The Decades of the New World* (1555), and many others. Eden's book contained a pirated summary of the voyage of Ferdinand Magellan, based on the original and longer work (in Italian), about giants, and kings, thieves, anthropophagi, and happy people who lived their lives stark naked.

Magellan had a tourist on board, who had not been assigned any duties, but turned out to be a close observer of the epic voyage with a taste for the exotic. He was Antonio Pigafetta, about 30 years old, Italian, from a privileged class, with friends in high places who eased his way onto the flagship. His journal is all we know of the three-year voyage around the world, from 1519 until 1522. It is through Pigafetta's eyes that we see Brazil, the risky passage through the Patagonian Straits, the lonely haul through the Pacific, the death of the captain in the Philippines, the long voyage home. His book was a sensation, though seamanship and conquest – the objects of the voyage – did not figure much in his brisk but impressionable narrative.

"They paint their entire bodies in the most marvelous manner, the women as well as the men, and they singe their bodies so that the men have no beards, nor do the women either have any hair…. They go about with their private parts uncovered, and completely hairless, both men and women. Their king is named Cachic. He has an infinite number of parrots and he gives eight or ten for a mirror."

So much for Brazil. What about the people of Guam? Magellan named it The Ladrones, because many of the islanders stole from the ships. "Each one of them lives according to his own wishes, having no king. They go about naked, and some wear beards, black hair, tied at the waist. They wear hats made of palm leaves, like the Albanians…. Their teeth are red and black, and they consider this to be very attractive. And they do not worship anything. The women are naked, except that they cover their privates with a thin bark that grows inside the palm trees, like a thin sheet of paper. They are beautiful and slender and lighter colored than the men; their hair is thick and black and reaches the ground."

In the outer islands of the Philippines, more nudists: "the people go about naked, they wear only a bit of cloth about their shameful parts."

In the Moluccas, a whole page of silks and combs, scarves and flowers. But of the straits, later named the Straits of Magellan, where there were mutinies and lost ships, Pigafetta's only story is of a Patagonian giant who was brought aboard, and how he became a Christian and spoke of "Setebos" – a word that Shakespeare put in Caliban's mouth in *The Tempest*.

In what was an astonishing feat of navigation, Pigafetta was dazzled more with naked islanders, recording colorful amazements rather than colder examples of science or seamanship. This, it seems to me, is the most human reaction. Such travelers' tales of extraordinary, innocent nakedness created an appetite for the exotic view, like the world before the Fall.

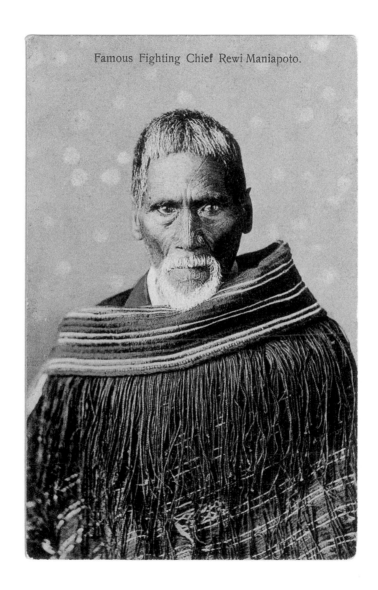

Famous Fighting Chief Rewi Maniapoto.

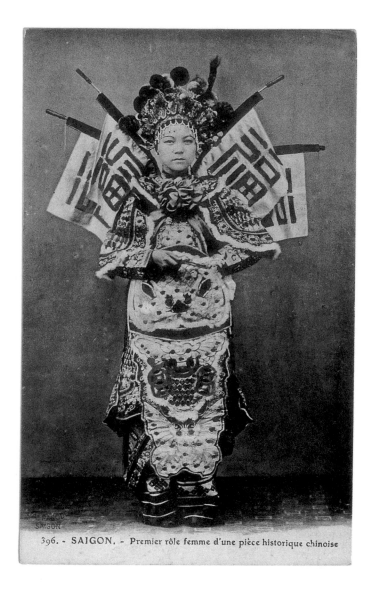

396. - SAIGON. - Premier rôle femme d'une pièce historique chinoise

Though Magellan sailed across the Pacific, through Polynesia, and most of Melanesia without sighting an island, it was the European encounter with Polynesia that helped define the exotic. It began one day in 1768, when a bare-breasted Tahitian girl climbed from her canoe onto a French ship under the hot-eyed gaze of 400 French sailors who had not seen any woman at all for over six months. She stepped onto the quarterdeck where, pausing at a hatchway, she slipped her flimsy pareu from her hips and stood naked and smiling at the men. Down went the anchor and in that moment the myth of romantic Tahiti was conceived, a paradise of fruit trees and brown breasts. Like Venus rising from the waves – that was how the naked girl was described by the captain of the ship, Louis Antoine de Bougainville, the first Frenchman in Tahiti, who believed he had discovered heaven on earth. He wrote, "I thought I was transported into the Garden of Eden."

His was also a pleasant shock of recognition. Only 15 years before, the philosopher Rousseau had described a version of this very scene, uncorrupted savages living in their natural state. Captain Bougainville was so ecstatic he paid Tahitian women his highest compliment: "for agreeable features [they] are not inferior to most European women; and who on the point of beauty of the body might, with much reason, vie with them all." He wrote that the naked girl on board "appeared to the eyes of all beholders, such as Venus showed herself to the Phrygian shepherd, having indeed, the celestial form of the goddess."

From that moment – and Bougainville encouraged the belief – Tahiti was known as the New Cytherea, the abode of Venus. The Tahitian girl was Venus made flesh, a goddess of love and beauty, the physical embodiment of the life force. Bougainville's account of his trip, *Voyage Around the World* (1771), made Tahiti a byword for the powerful pull of the exotic. Inspired by this book, Lord Byron wrote a poem on the subject, Diderot wrote a novel, Melville sailed there in a whaling ship, and wrote about it, and Robert Louis Stevenson also paid a visit, with a view to settling (he chose Samoa because it had a better mail service). Pierre Loti traveled to Polynesia and married a Tahitian and described it. As soon as he read Loti, Gauguin headed for Polynesia. And all these men left us vivid images of island exoticism.

These men did something else. They testified to the transformative powers of the exotic. In such happy places, where people do things differently, we can share their joy and alter our lives. We know this power of the exotic from Stevenson's writings in Samoa, Mark Twain's in Hawaii, Karen Blixen's in Africa, the reinforcing imagery of a kind of Eden, or a place where we have a second chance.

There is another version, a disappointing, even dark one. This hopeful dream, one of the stronger impulses in travel, can also be subverted. We have the salutary lesson of Rimbaud, who in his late teens wrote passionately, lyrically, creating a whole poetry of the exotic; and then he upped and traveled to the Far East and to Aden, where he worked for a coffee exporter, and still searching, traveled farther to Harar in Abyssinia. He dealt in coffee and smuggled firearms, but in all his travels never wrote another line of poetry. Was he bewitched? Not really, he wrote home, complaining of Harar, "It's a wretched life anyway, don't you think — no family, no intellectual activity, lost among blacks who try to exploit you and make it impossible to settle business quickly? Forced to speak their gibberish, to eat their filthy food and suffer a thousand aggravations caused by their idleness, treachery and stupidity! And there's something even sadder than that — it's the fear of gradually turning into an idiot oneself, stranded as one is, far from intelligent company."

The intellectual life seldom if ever figures in a contemplation of the exotic. Pure sensuality, or delicious comfort, sunshine and fruit trees, seem to exclude a life of the mind. In sunny Coronado, California in the warm spring of 1905, Henry James (who was taking a sentimental journey through his native land) wrote, "California…has completely bowled me over — such a delicious difference from the rest of the U.S. do I find in it." And then quickly adds, "I speak of course all of nature and climate, fruits and flowers; for there is absolutely nothing else, and the sense of the shining social and human inane is utter."

That is the far side of Paradise.

Apart from the characterization of the exotic being like the Garden of Eden, the usual metaphors for the exotic are invariably classical, pre-Christian, pagan, innocent. That the exotic is not Christian is undoubtedly part of its appeal; it is not religious, not even political except where a chief or a king is concerned. With the Christian element removed, the concepts of sin and guilt are absent. In this world of innocence, purity and gentleness, the exotic very often calls to mind a peaceable kingdom, in which every dream girl is a princess and every man a protector. The exotic image is not explicitly erotic but often subtly sensual, which is why we seldom associate elderliness with exoticism and so often, in imagining this world, conceive a mental image of youth, of children, or of the child-like. Part of the formula which goes to make up this dream relates to time and good health. In the world of the exotic, which is always an old world peopled by the young or the ageless, time stands still.

It goes almost without saying that the exotic notion is a Western dream, initially a European hankering for the East that became more generalized geographically, and came to include an idealized North America, and then the Pacific islands and North Africa, the Near East, and the more sinuous races living among fragrant blossoms in South America.

The exotic dream, not always outlandish, is a dream of something we lack, something we crave. It may be the naked islander, or the childlike odalisque squinting from her sofa with her hands behind her head, or else a glimpse of palm trees, since the palm tree is the very emblem of the exotic. It is also the immediately recognizable charm of the unfamiliar, and so the Maori elder, the Famous Fighting Chief, Rewi Maniapoto, counts as much as the dancing girl. But always the exotic is elsewhere. The word itself implies distance, as far from the world of home and scheming as Prospero's island of magic and exile is from Milan. It is the persuasive power of travelers' tales, the record of enormous journeys of quest and discovery; the heroism of these returned travelers is the glorious note of enchantment in their stories.

It seems as natural to dream of the exotic as to dream at all. We are born with an impulse to wonder and, eventually, to yearn for the world before the Fall in which we may be the solitary Crusoe, the guiltless adventurer, the princeling with a jeweled sword. Because the dream's perfection suggests that it is unattainable, man searches for proof that it is not. And whatever fantasy one has reveals one's peculiar hunger. It might be very simple: the sunny

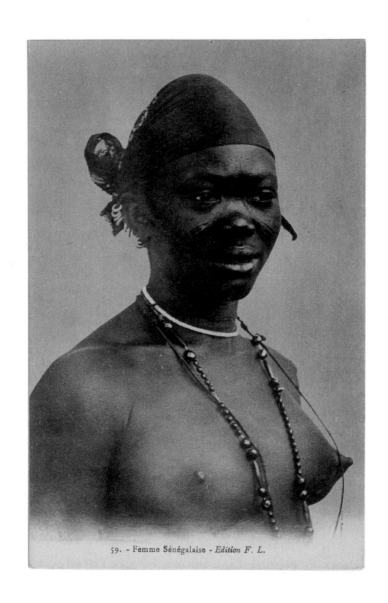

59. - Femme Sénégalaise - *Edition F. L.*

island paradise. Or it might be complex: the oriental kingdom of silks and plumes.

However ornate or imposing the architecture, the monuments, the palaces, they are the background; in the foreground of the exotic are people. Flaubert, almost a caricature of the orientalist, with his stereotype of Araby, went to Egypt in 1849 and described the markets, the pyramids, the temples, and the Sphinx. The Sphinx cast its spell on him ("fixes us with a terrifying stare"), but shortly afterward the spell was broken ("Its eyes still seem full of life; the left side is stained by bird-droppings"). It was the people – specifically the women – who captivated him.

Flaubert's mission was to meet a famous courtesan named Kuchuk Hanem and watch her perform the Dance of the Bee. When some months later he met her in Esna, he had much less to say about the great temple there (six lines) than the object of his desire: "Kuchuk Hanem is a tall, splendid creature, lighter in color than an Arab…. When she bends, her flesh ripples into bronze ridges. Her eyes are dark and enormous, her eyebrows black, her nostrils open and wide; heavy shoulders, full, apple-shaped breasts," and so forth for almost a whole page – her coiffure, her jewelry, her teeth, her tattoo, even her knee caps. Shortly after meeting Kuchuk, he made love to her, which he recounted in three more purple pages, in which he included a closely observed description of the Dance of the Bee. Kuchuk performed naked, while the musicians were blindfolded, and the next day Flaubert made love to her again. So much for sightseeing in Esna.

Flaubert's friend and traveling companion, Maxime du Camp, had brought a camera with him to Egypt. He was among the first to photograph scenes of Egypt, though he only managed to take one picture of the camera-shy Flaubert.

Much of the lure of what we know of the exotic springs from photographs. In the beginning, photography was the proof that the exotic was not the confidence trick of the traveling painters or the sketchers on board the ships of discovery. What is it about a photograph that is so convincing? Perhaps, however fudged or posed, photographs possess an accidental truthfulness, resulting from the undiscriminating lens rather than the selective human eye. In some cases they may be distortions of the exotic dream,

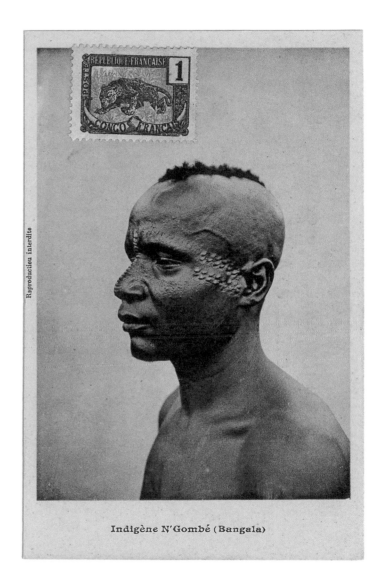

Reproduction interdite

Indigène N'Gombé (Bangala)

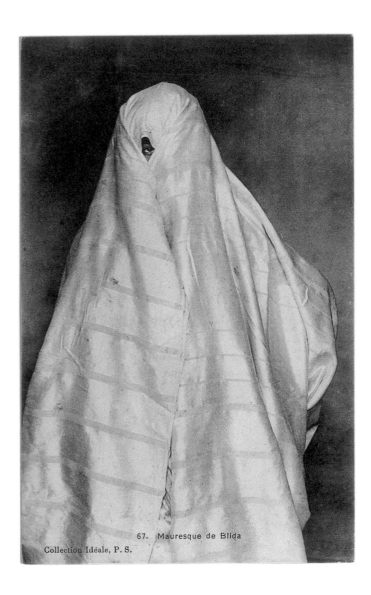

67. Mauresque de Blida
Collection Idéale, P. S.

rougher bruised-looking, or plainly grubby; but many are like the dream made flesh and have an uncanny exactitude. They are representations of a complete world that is utterly different from that inhabited by people in whose dreams this exoticism was prefigured. This is the world in a dewdrop, trembling on a very odd leaf. Photographs of the exotic enlarge the meaning of the word and go on to furnish our dreams with imagery of greater undreamed-of magnificence.

Each such picture is an excitement, an invitation to the exotic and seems to repeat in its strangeness that this is a world that awaits further discovery. It holds out the promise (which is also the promise of pornography, a genre on which some of these images overlap) that you can enter this picture. Because it is a photograph it is an affirmation of truth, even though we know that photographs are capable of trickery and cheating. After its clumsy beginnings in the 1820s and 1830s photography developed swiftly and the photograph as we know it dates from the middle of the 19th century. The camera intensified the lure of the exotic and made it seem attainable.

The first postal card – just a card for a message – was issued in Austria in 1869. By the end of the century this artifact had evolved into the picture postcard that was briskly used in the way it is now, as a hello, an I'm-all-right signal, and frequently a boast. Because it can so easily be read by a stranger, the message on a postcard seldom contains anything intimate or important, nothing crucial, never a secret, nothing you wouldn't want the postman to see. Why do travelers send postcards? To get a rise out of the people at home – to shock them, tempt them, one-up them. To deceive some people; to make them envious. To confirm their stereotype of The Other, to emphasize distance in a journey. Busy people send them. They are like very slow telegrams. They are a traveler's expedient, demonstrating economy of effort. The choice of card tells you something about the people who send them; and perhaps something of those who receive them.

The apotheosis of picture postcards occurred at a time when the lure of the exotic was at a peak. They were sent in great numbers and variety at the height of European colonialism, in the decades before the First World War, when Britain, France and Germany ruled half the earth. The imperial powers exploited their

colonies without improving them much, putting in railways and roads only where they made it easier to export a product. Most of the indigenous people were untouched by these efforts. So the postcards here represent the pretensions of a period of idealized innocence, when few outsiders traveled to these parts of the world; when it was possible to dazzle the people at home with such images. It was not a golden age but seemed to be. And it was distant, less a world than a universe of almost inaccessible places. Scribbled on the back of one postcard here, from Noumea on New Caledonia is a reference to "Notre long voyage de 45 jours."

The paradox in the portraits of the warriors here is that though they are fierce-looking they are obviously conquerable. The Kikuyu, the Ethiopian ("Cavalier abyssin"), the Tuareg in full battle gear, the Masai moran, the martial-looking Fijian, the soldierly Maori, all with shields and spears and clubs; none of them seems dangerous, only colorful and outdated.

Much of the world now dresses alike. One of the great cultural transformations of the present has been the abandonment of traditional dress in favor of cheap clothes made in India and China. These postcards represent a vanished world of peculiar costumes, maybe the last gasp of such dressing-up – Korean wedding garb, the Nepalese girl with five necklaces, the "Indian woman" (hardly more than a young teenager) completely decked out; the Chinese mandarin, an assortment of complex coiffures; "Chérifa – Jeune fille Somali," enigmatic in her silk dress, the leopard skin beneath her feet, the apparel of chieftainship; and royalty, kings in formal regalia, like the Oba of Benin in his drum-like skirt, or the boy-child Kabaka of Buganda; the covered-up Moroccans, the Guatemalans in robes, a world of accessories and costumes.

In great contrast to the impenetrable thicknesses of age-old costumes and brocades, there is nakedness. The postcards are a record of the naked body around the world in all its postures. This is a reminder that the lure of the exotic is bound up with the world of bare, always brown breasts – Tunisian, Laotian, Ifugao, Samoan, Tahitian. Many of them are labeled, with a wink, "Une beauté" or "Jeunes Femmes," "A Zulu beau." But we know them to be schoolgirls, dancers, musicians, brides, and obvious prostitutes, amounting almost to vignettes, many of them subtly beckoning.

They are intentionally teasing, shocking, twitting, and challenging our assumptions, implying that though we may have dreamed of such excitements we have never seen such images before. Here is "Head hunter's home, Luzon," and the trussed and ghoulish-looking shrunken head from Ecuador, the "Kaffir Wizard," who doesn't look dangerous and the "Dyaks, wild men of Borneo" who do look fairly menacing. And there are elements of the sideshow, if not freak show, with some others, notably "Leopard skin Kaffir child with his mother."

"Le maroc pittoresque" is the rubric on one postcard. That says a lot. Many of these images could be described as "pittoresque," for that's one of the exotic's main qualifications. Because they are posed and so deliberate, many of these portraits unintentionally depict people as sculptural forms. The "Indigène N'Gombé (Bangala)" like an ebony bust of a man with scarified face, the heap of marmoreal-seeming robes with one eye peeking out, "Mauresque de Blida," and the man who seems indistinguishable from a statue, in "Types Chinois du Quang-Si – Bonze en tenue d'officiant." They could easily be elaborate carvings.

You are left wondering what ethnographic value these images have, if any. There is no question of the authenticity in the modes of dress, and the weapons, the finery, the jewelry. I can speak to the Pacific clubs, which I have studied. Each form of Oceanic club shown here has a specific name and function – the short Maori patu for close combat, the Fijian kiakavo for breaking bones, the Samoan toothed club for cracking open the enemy's head. But they are also badges of authority. Some pictures of them exist, but these photographs give function and vitality to their ownership.

The romance of these images is undeniable, and there is a sense of theater about them, too; posturing, hints of the obedient native. But ultimately this narrative of a lost world is less about the subjects than the ones intended to be thrilled or titillated or tempted to drop everything and leave home to crouch in the fo'c'sle. They say everything about the people who need to be furnished with images for our dreams. That would be us, the recipients of the postcards.

PAUL THEROUX

ASIA

WONDERS OF THE EAST

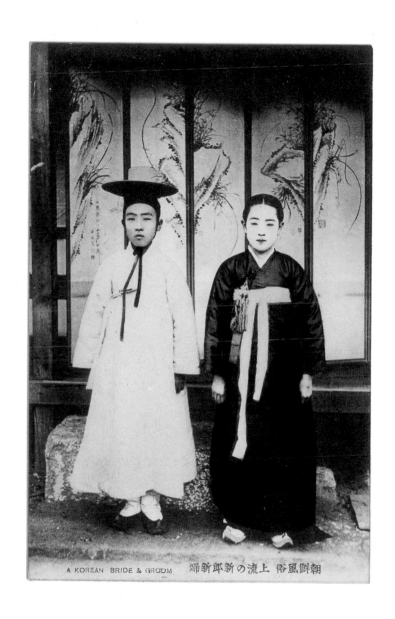

A KOREAN BRIDE & GROOM　朝鮮風俗　上流の新郎新婦

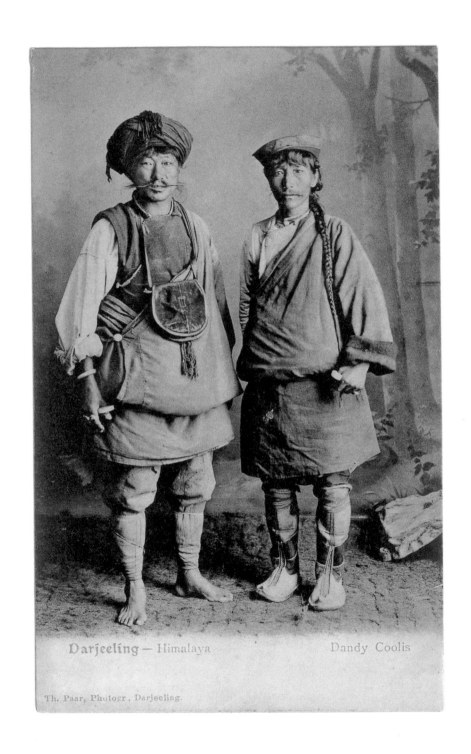

Darjeeling — Himalaya Dandy Coolis

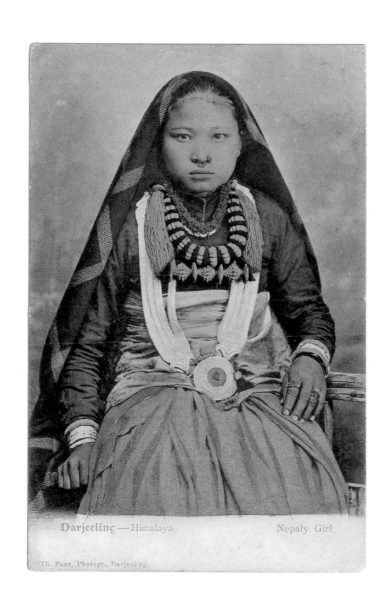

Darjeeling — Himalaya Nepaly Girl

17

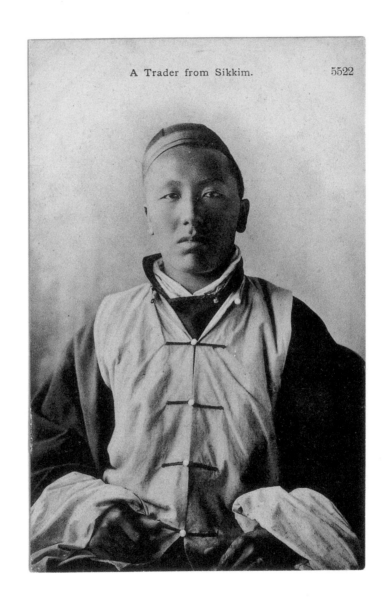

A Trader from Sikkim. 5522

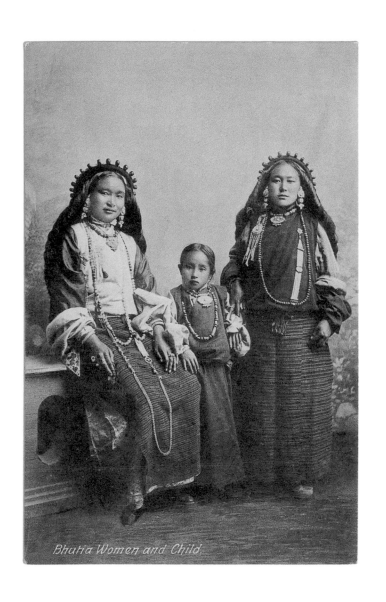

Bhutia Women and Child.

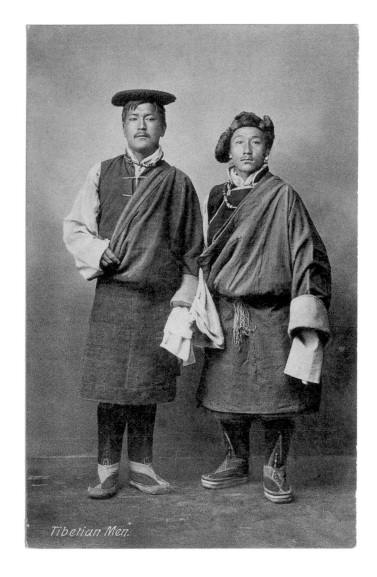

Tibetian Men.

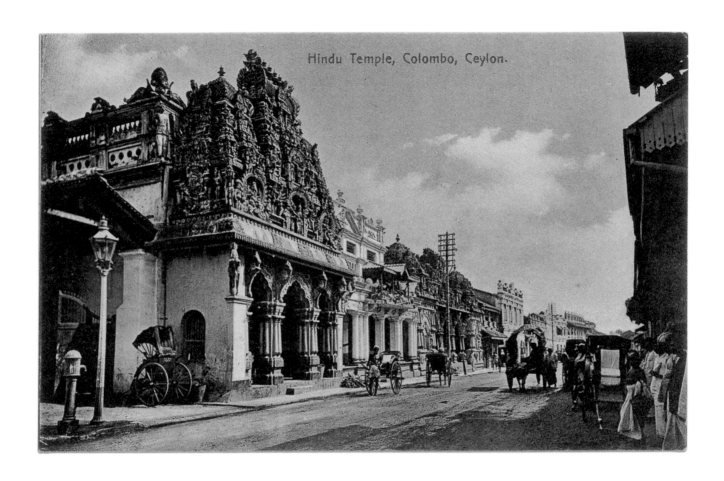

Hindu Temple, Colombo, Ceylon.

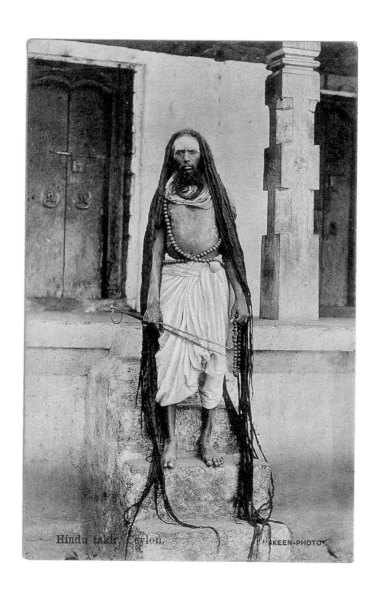

Hindu fakir Ceylon. KEEN-PHOTO

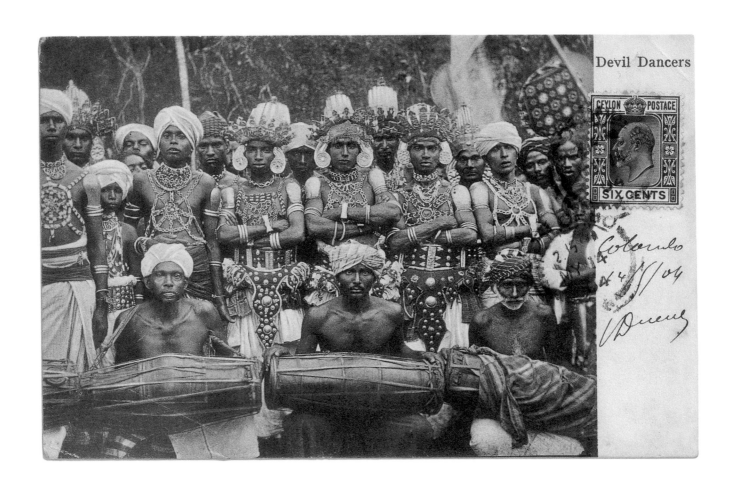

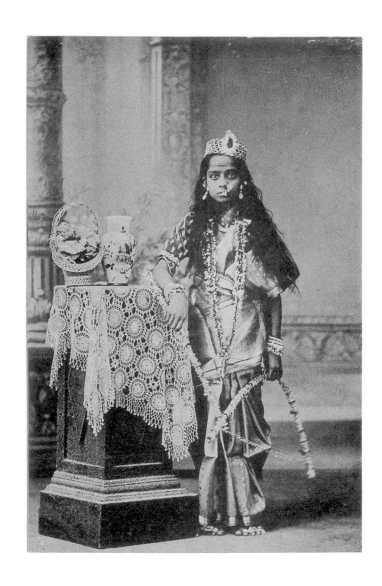

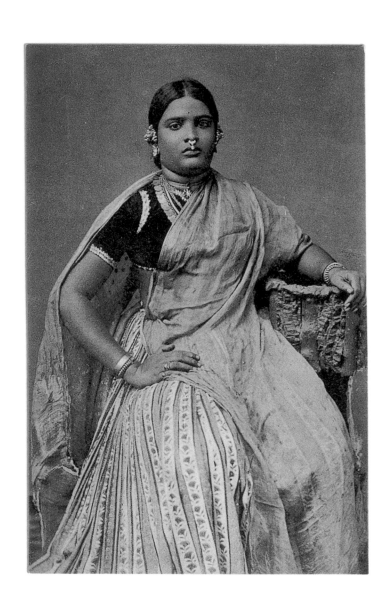

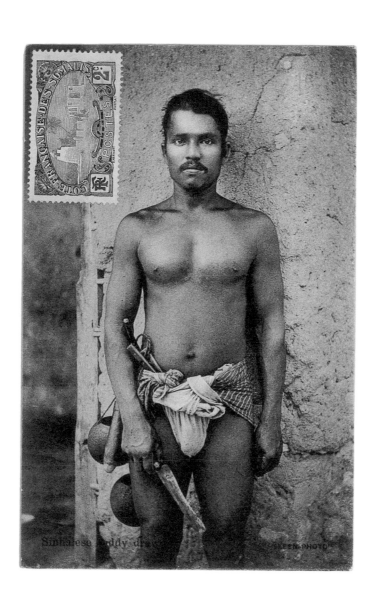

Sinhalese ~~paddy~~ ~~dr~~ ... KEEN PHOTO

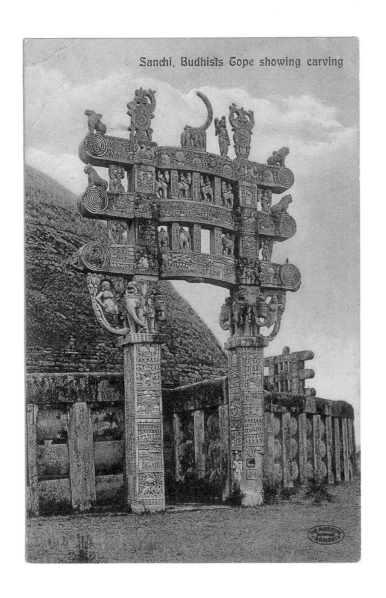

Sanchi, Budhists Tope showing carving

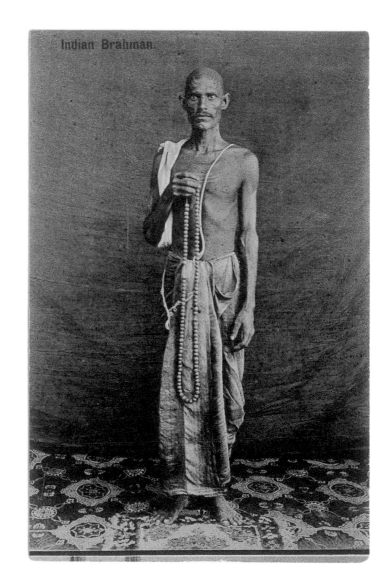

Indian Brahman.

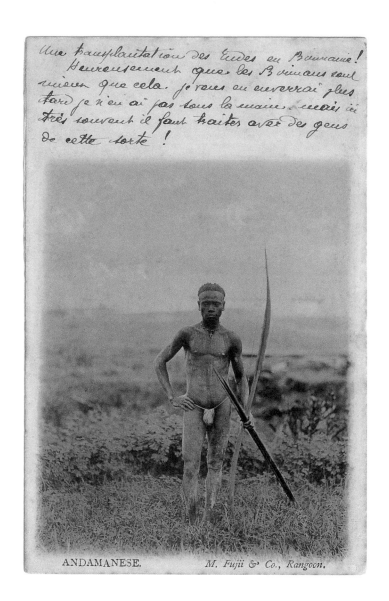

Une transplantation des Indes en Birmanie !
Heureusement que les Birmans sont
mieux que cela. Je vous en enverrai plus
tard je n'en ai pas sous la main. Mais ici
très souvent il faut traiter avec des gens
de cette sorte !

ANDAMANESE. M. Fujii & Co., Rangoon.

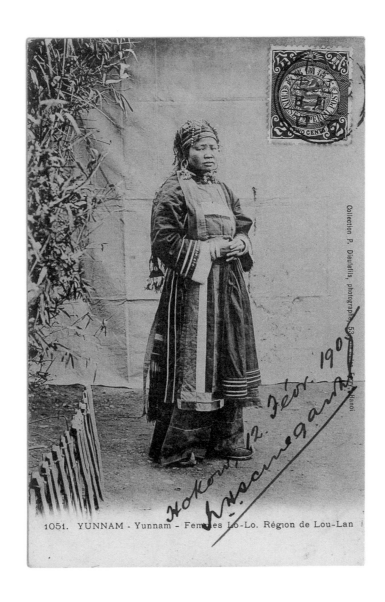

1051. YUNNAM - Yunnam - Femmes Lo-Lo. Région de Lou-Lan

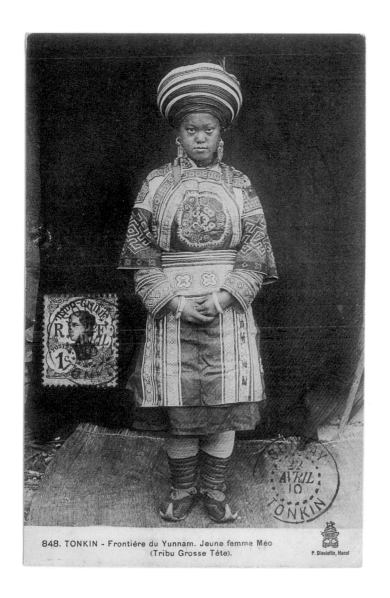

848. TONKIN - Frontière du Yunnam. Jeune femme Méo
(Tribu Grosse Tête).

P. Dieulefils, Hanoï

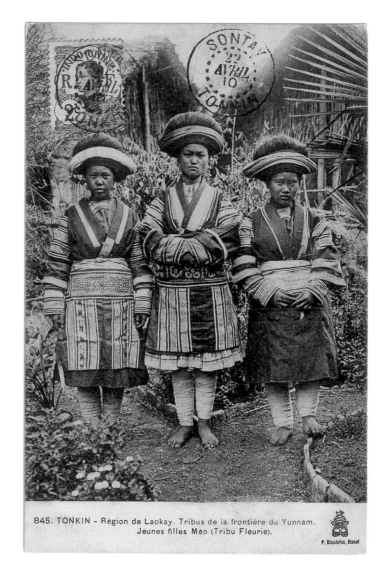

845. TONKIN - Région de Laokay. Tribus de la frontière du Yunnam.
Jeunes filles Méo (Tribu Fleurie).

P. Dieulefils, Hanoï

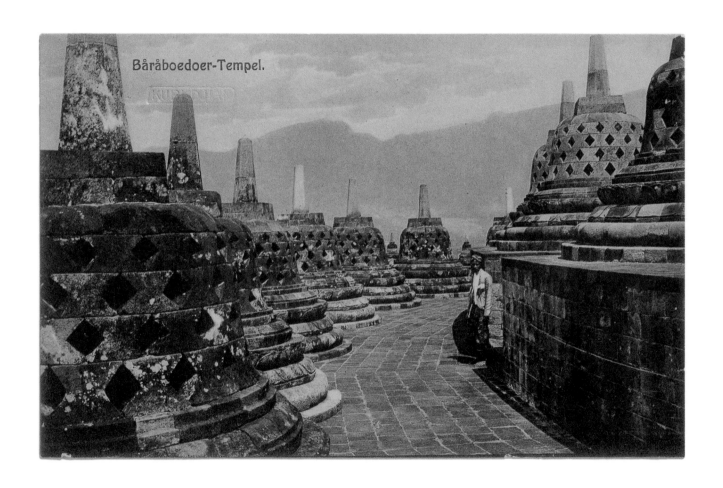

Båråboedoer-Tempel.

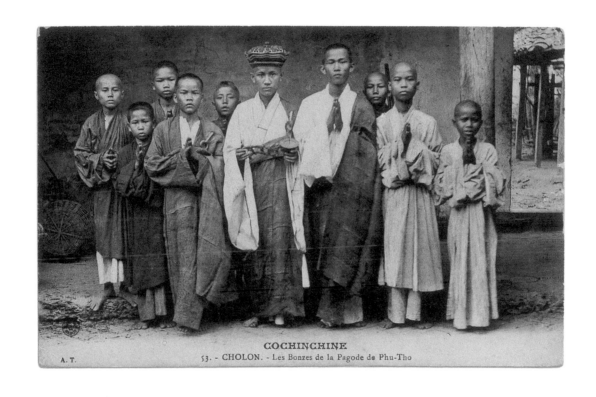

COCHINCHINE

A. T. 53. - CHOLON. - Les Bonzes de la Pagode de Phu-Tho

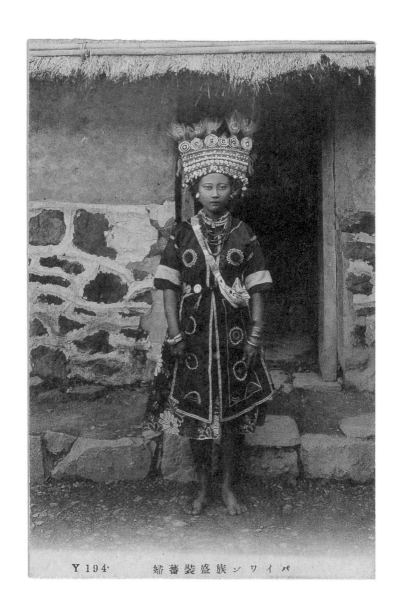

Y 194 婦裝盛族ンワイパ

34

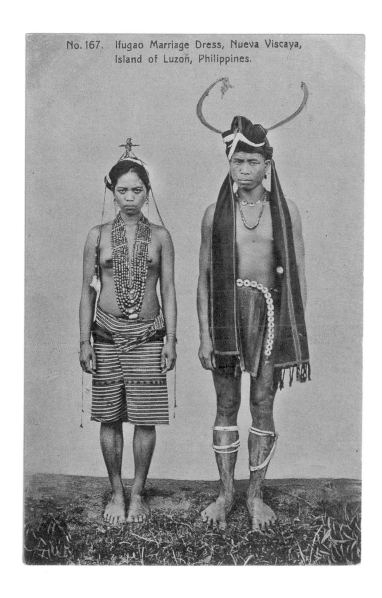

No. 167. Ifugao Marriage Dress, Nueva Viscaya,
Island of Luzon, Philippines.

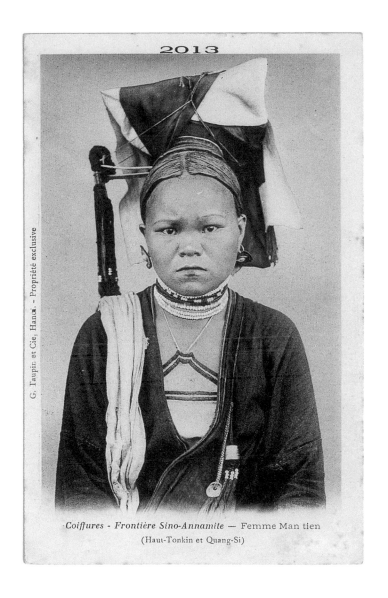

2013

G. Taupin et Cie, Hanoï. - Propriété exclusive

Coiffures - Frontière Sino-Annamite — Femme Man tien
(Haut-Tonkin et Quang-Si)

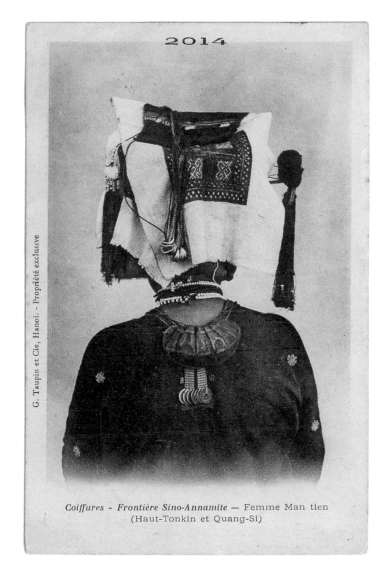

2014

G. Taupin et Cie, Hanoï. - Propriété exclusive

Coiffures - Frontière Sino-Annamite — Femme Man tien
(Haut-Tonkin et Quang-Si)

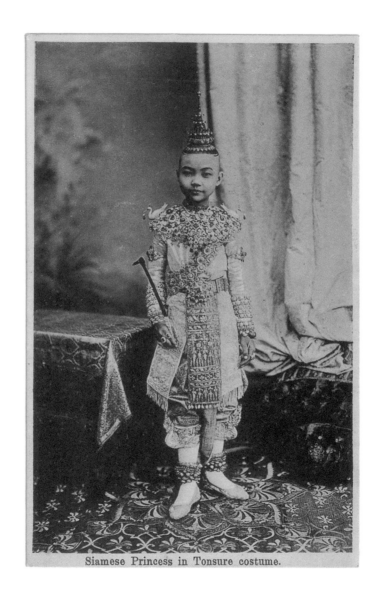

Siamese Princess in Tonsure costume.

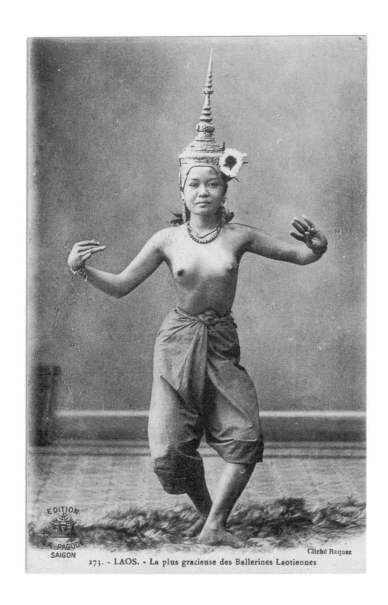

EDITION
LA PAGODE
SAIGON

Cliché Raquez

273. - LAOS. - La plus gracieuse des Ballerines Laotiennes

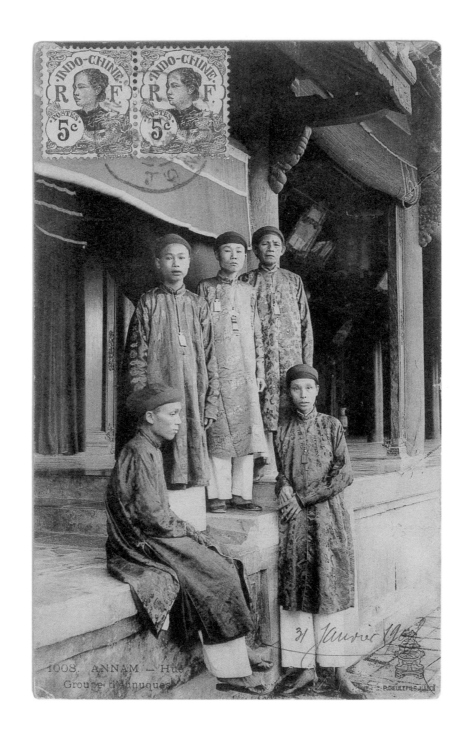

1008. ANNAM — Hue
Groupe d'Annuques

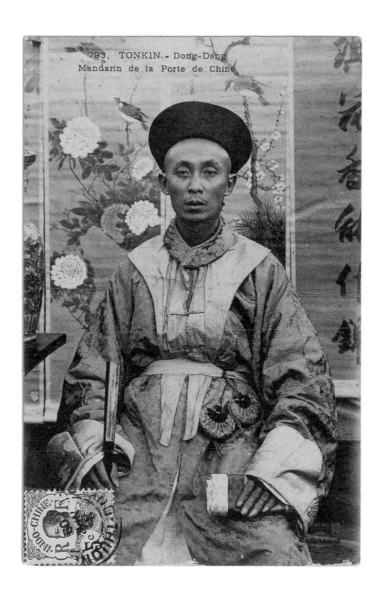

793. TONKIN. - Dong-Dang
Mandarin de la Porte de Chine

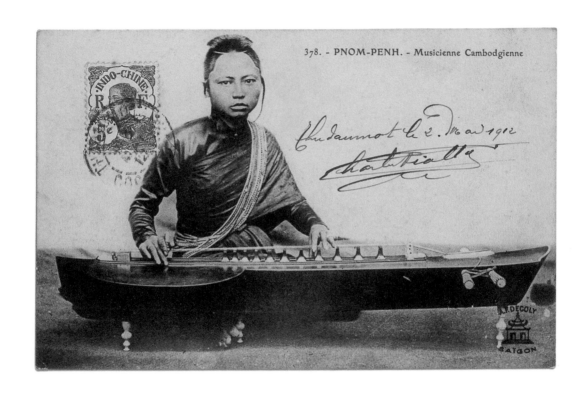

378. - PNOM-PENH. - Musicienne Cambodgienne

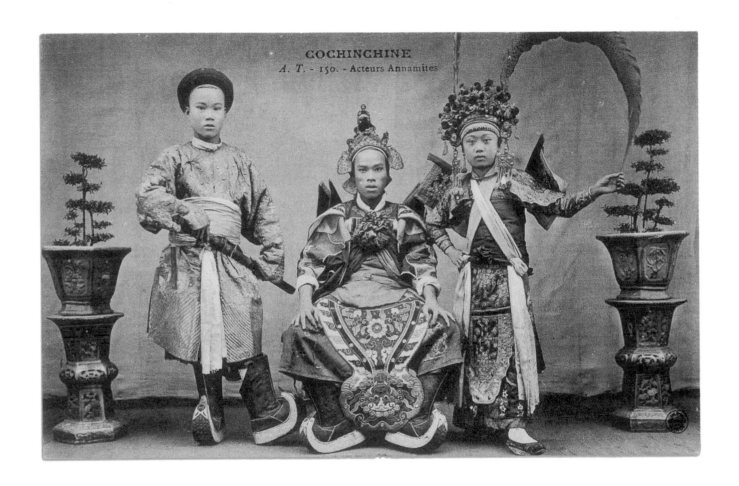

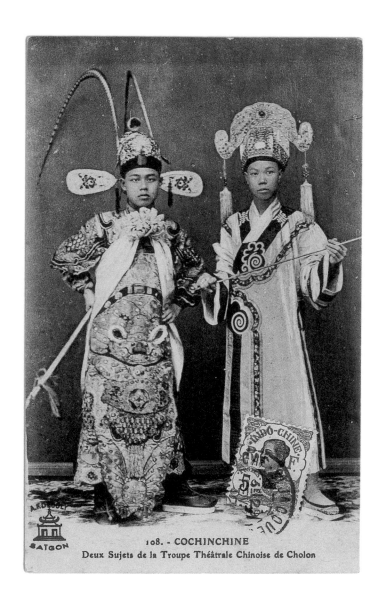

108. - COCHINCHINE
Deux Sujets de la Troupe Théâtrale Chinoise de Cholon

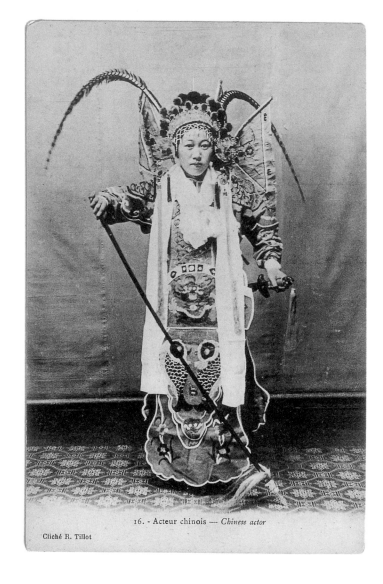

16. - Acteur chinois — *Chinese actor*

Cliché R. Tillot

44

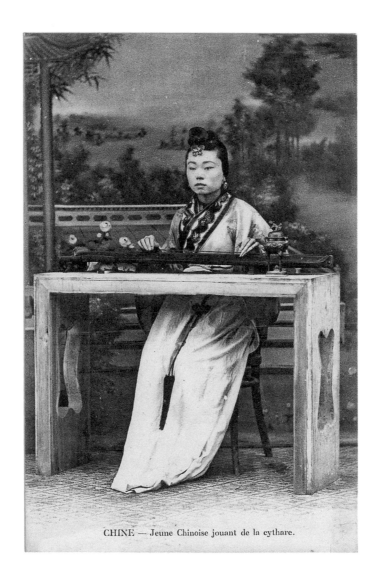

CHINE — Jeune Chinoise jouant de la cythare.

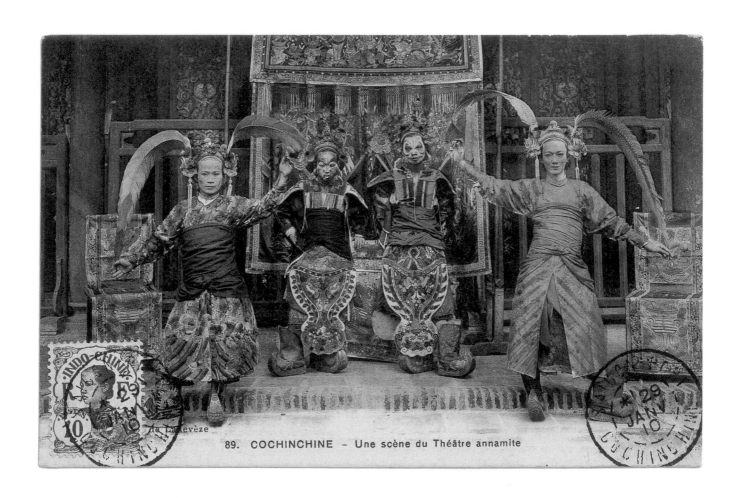

89. COCHINCHINE – Une scène du Théâtre annamite

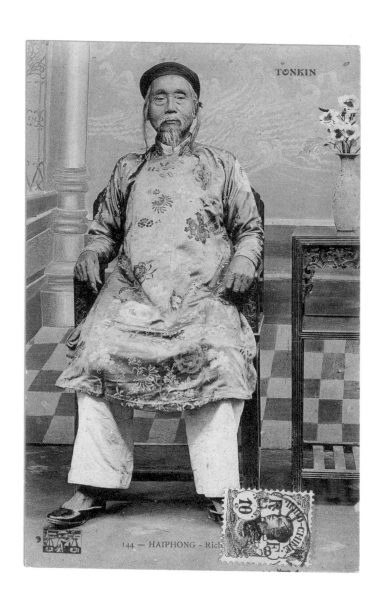

TONKIN

144 — HAIPHONG - Rich

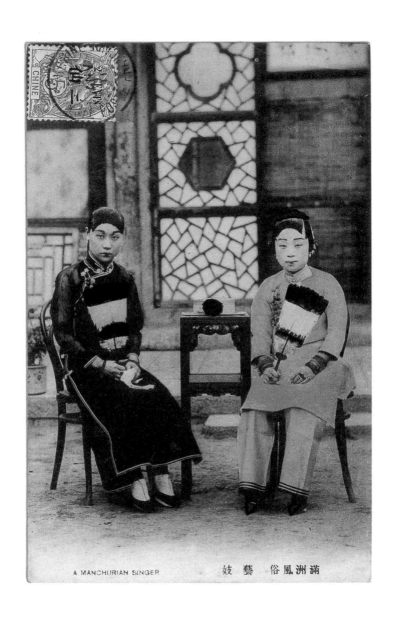

A MANCHURIAN SINGER　　　滿洲風俗　藝妓

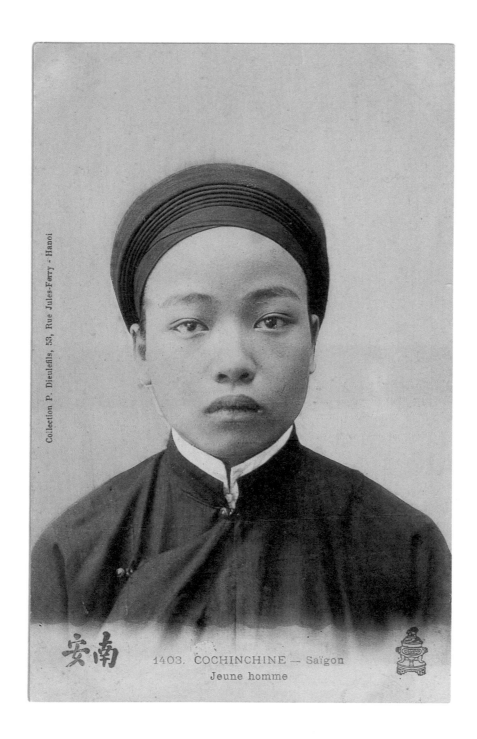

安南

1403. COCHINCHINE — Saïgon
Jeune homme

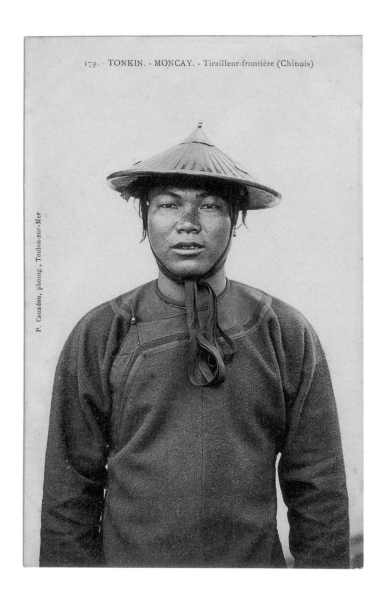

179. - TONKIN. - MONCAY. - Tirailleur-frontière (Chinois)

P. Couadou, photog., Toulon-sur-Mer

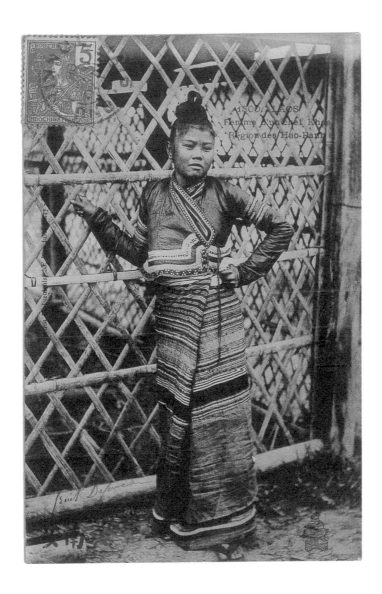

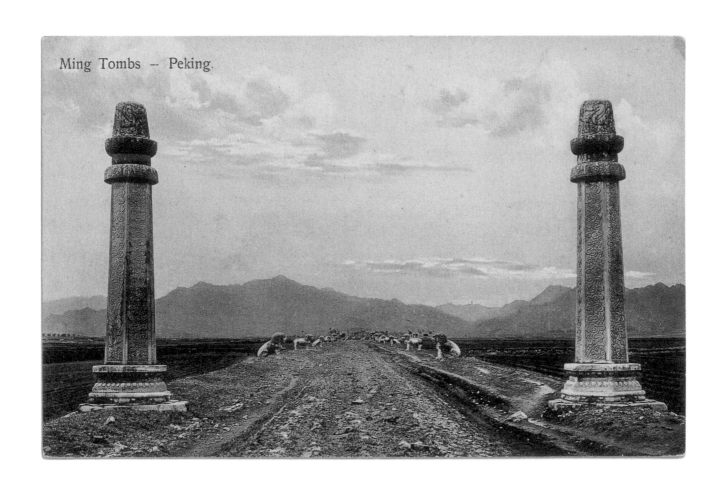

Ming Tombs -- Peking.

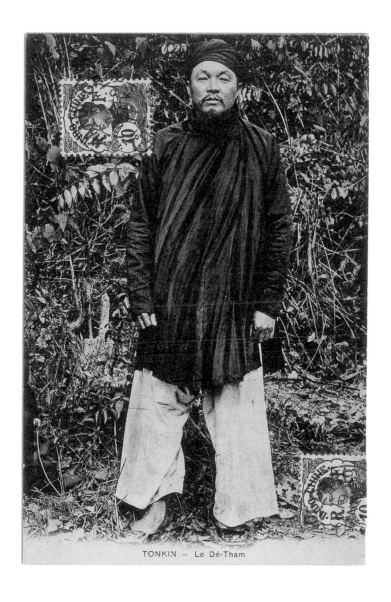

TONKIN – Le Dé-Tham

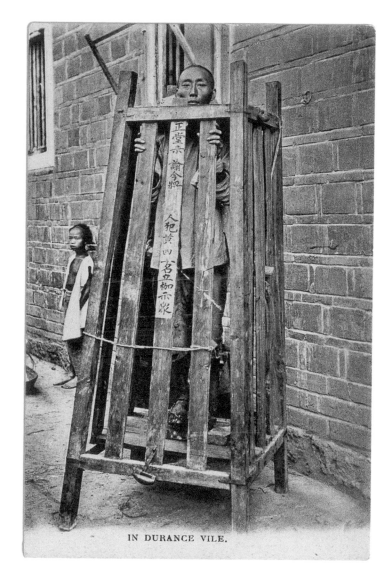

正堂示
諭令枷
人犯黃四
名立枷示眾

IN DURANCE VILE.

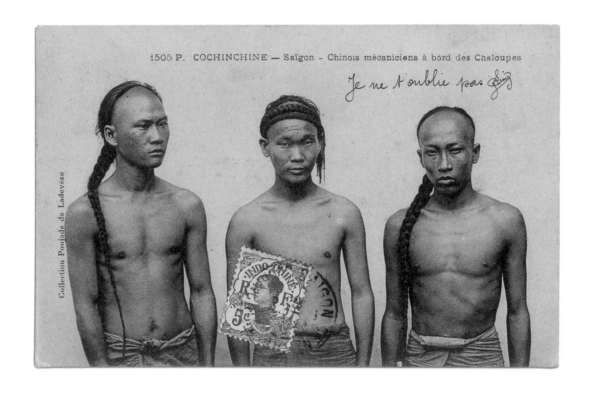

1505 P. COCHINCHINE — Saïgon - Chinois mécaniciens à bòrd des Chaloupes

Je ne t'oublie pas

Collection Pouiade de Ladevèze

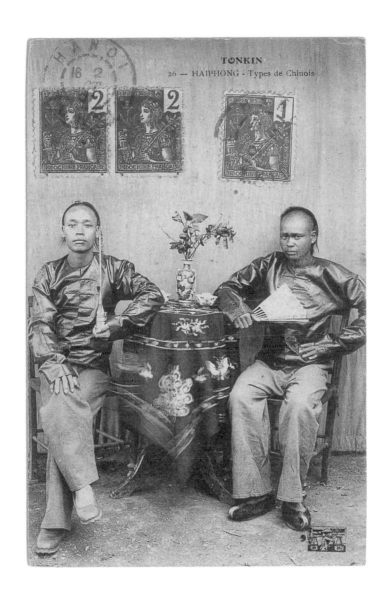

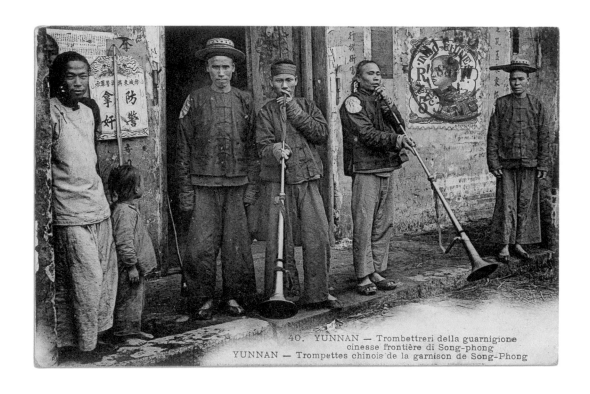

40. YUNNAN — Trombettreri della guarnigione
cinesse frontière di Song-phong
YUNNAN — Trompettes chinois de la garnison de Song-Phong

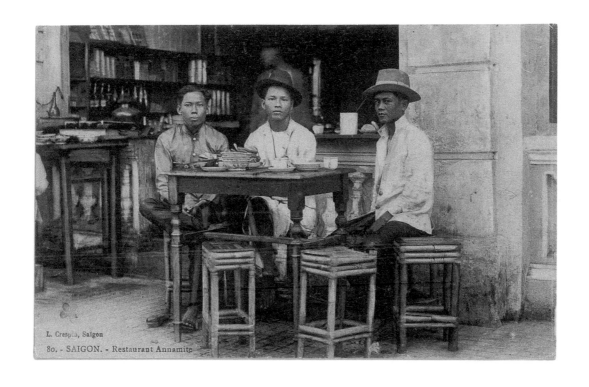

L. Crespin, Saïgon

80. - SAIGON. - Restaurant Annamite

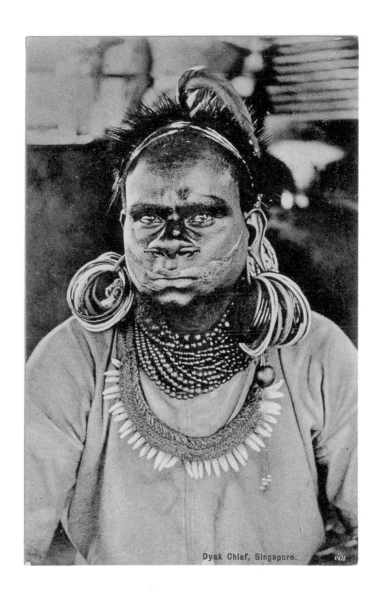

Dyak Chief, Singapore.

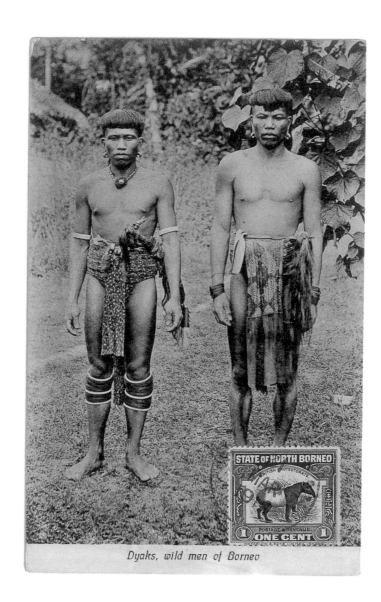

Dyaks, wild men of Borneo

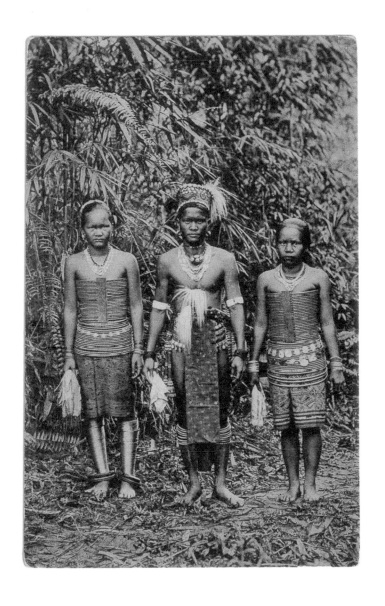

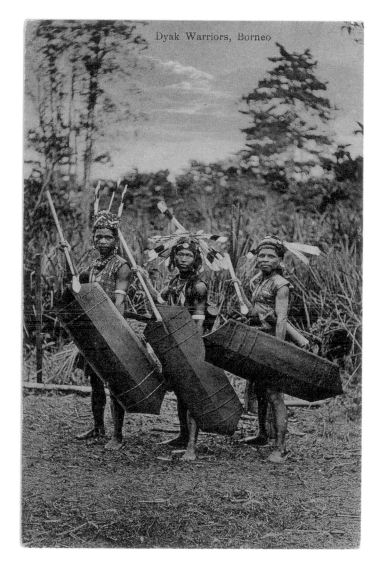

Dyak Warriors, Borneo

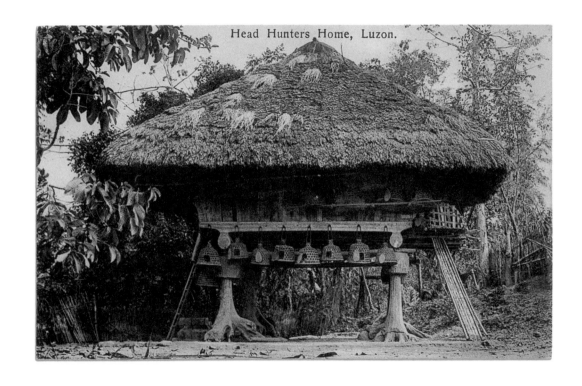

Head Hunters Home, Luzon.

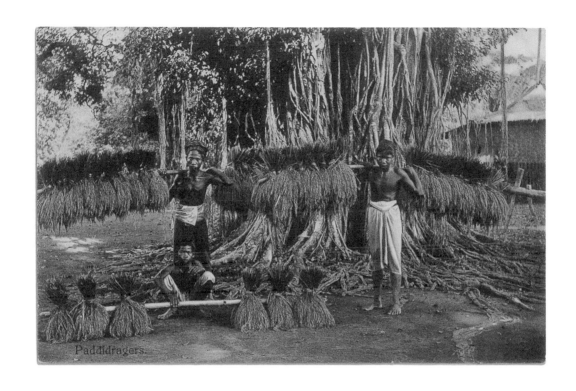

Paddidragers.

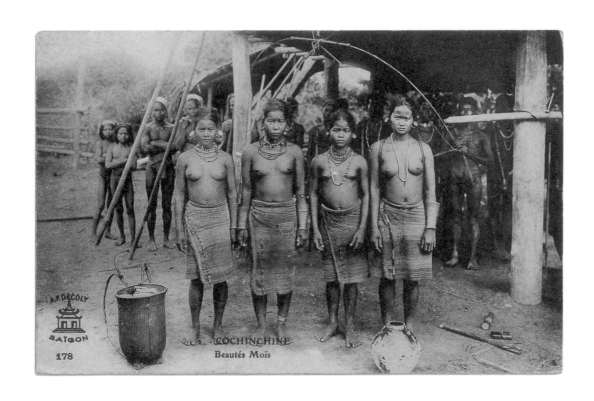

COCHINCHINE
Beautés Moïs

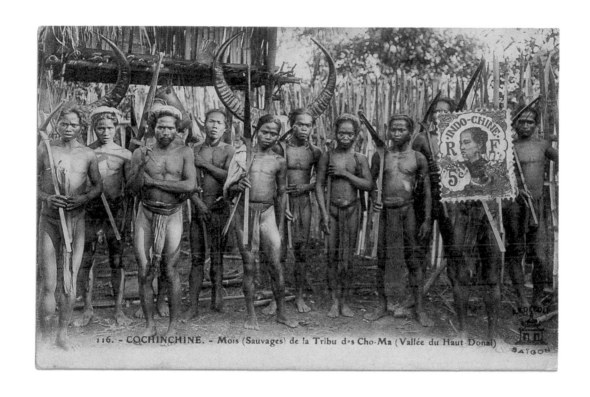

116. - COCHINCHINE. - Mois (Sauvages) de la Tribu des Cho-Ma (Vallée du Haut Donai)

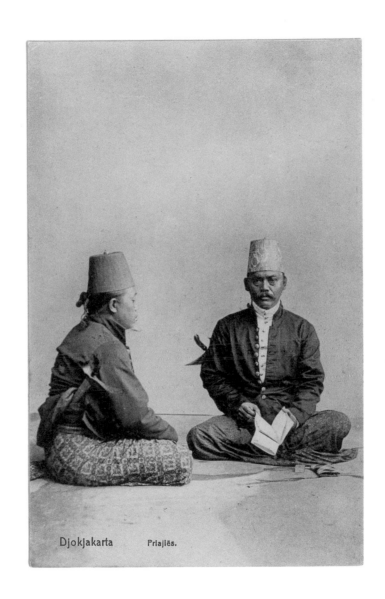

Djokjakarta Priajĕs.

神宮式年遷宮記念

豐受大神宮

皇大神宮

68

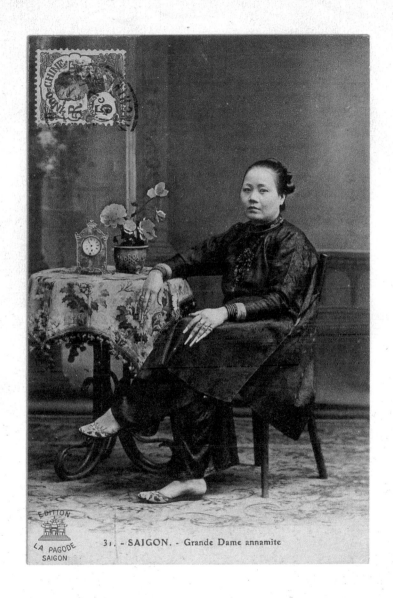

31. - SAIGON. - Grande Dame annamite

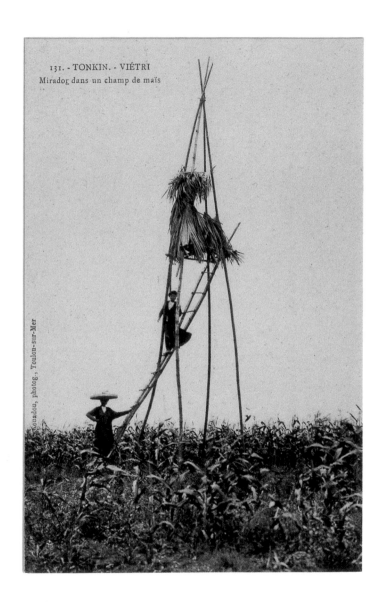

131. - TONKIN. - VIÉTRI
Mirador dans un champ de maïs

Roualou, photog., Toulon-sur-Mer

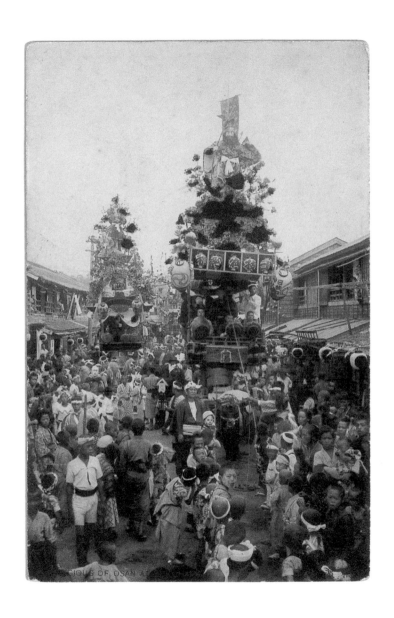

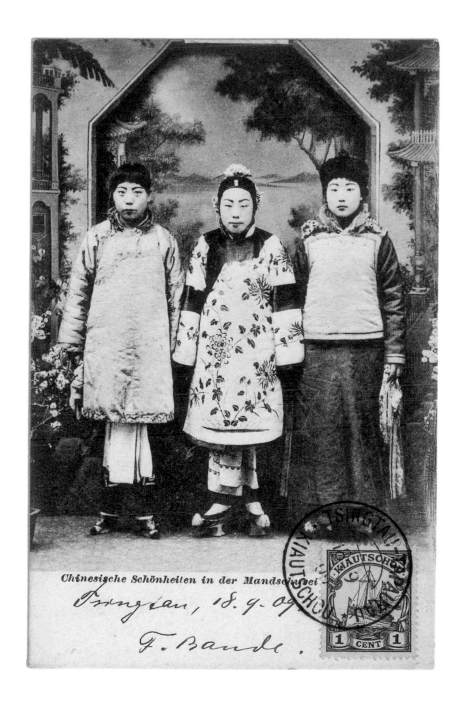

Chinesische Schönheiten in der Mandschurei

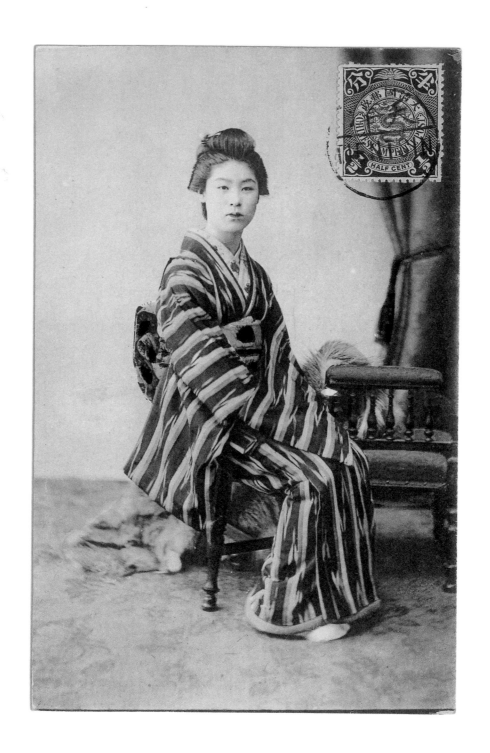

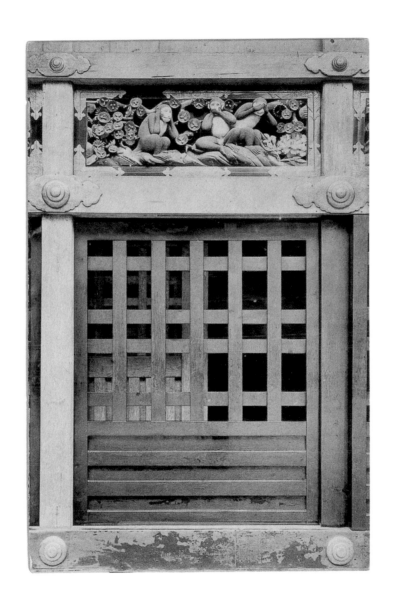

OCEANIA

MYRIAD ISLANDS IN AN AZURE SEA

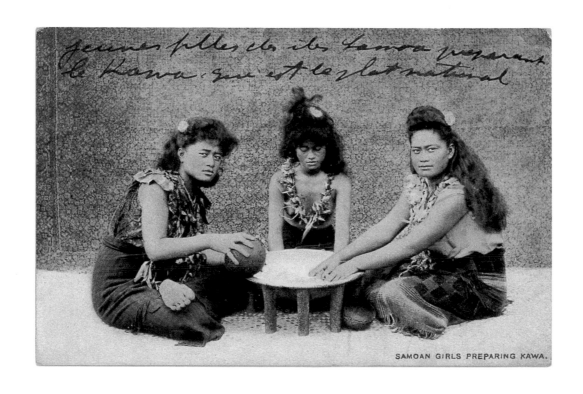

SAMOAN GIRLS PREPARING KAWA.

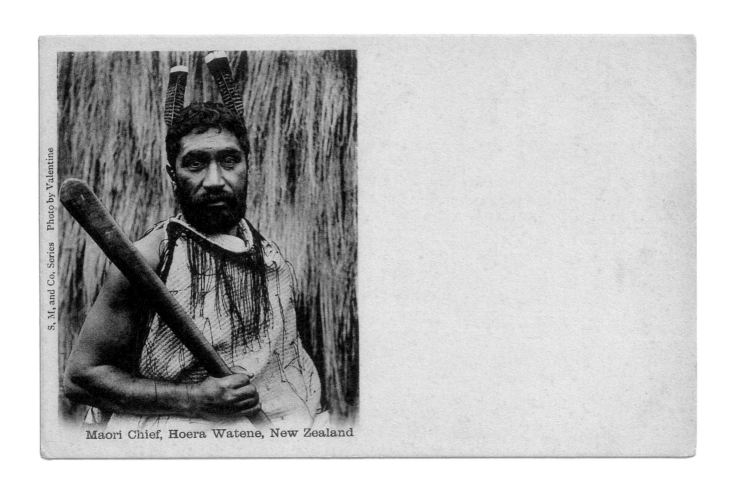

S, M, and Co, Series Photo by Valentine

Maori Chief, Hoera Watene, New Zealand

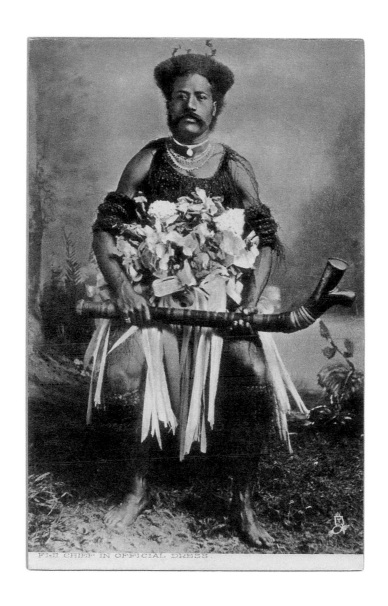

FIJI CHIEF IN OFFICIAL DRESS.

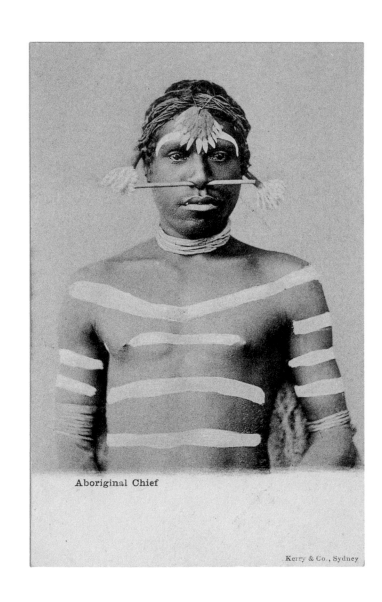

Aboriginal Chief

Kerry & Co., Sydney

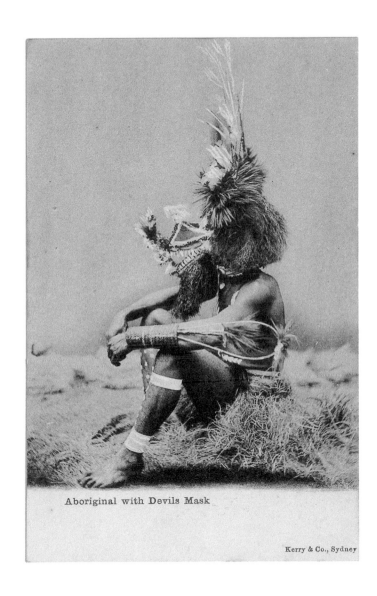

Aboriginal with Devils Mask

Kerry & Co., Sydney

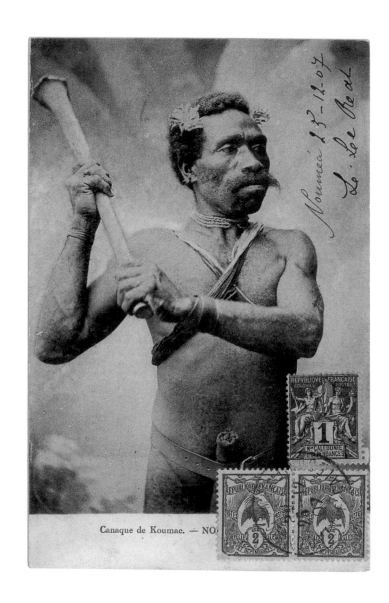

Canaque de Koumac. — NO

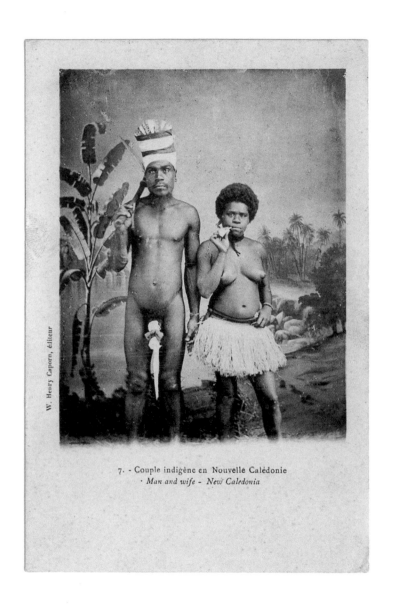

W. Henry Caporn, éditeur

7. - Couple indigène en Nouvelle Calédonie
Man and wife - New Caledonia

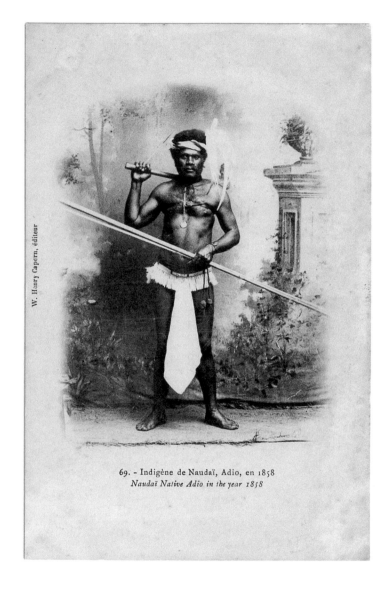

W. Henry Caporn, éditeur

69. - Indigène de Naudaï, Adio, en 1858
Naudaï Native Adio in the year 1858

83

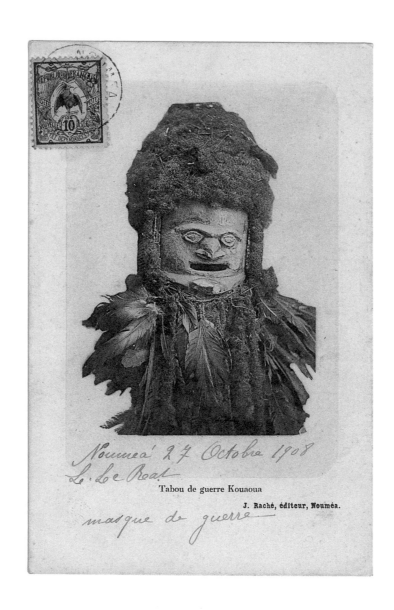

Nouméa 27 Octobre 1908
L. Le Rat

Tabou de guerre Kouaoua

J. Raché, éditeur, Nouméa.

masque de guerre

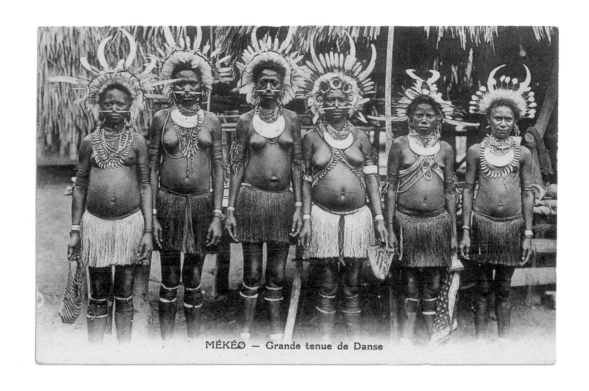

MÉKÉO — Grande tenue de Danse

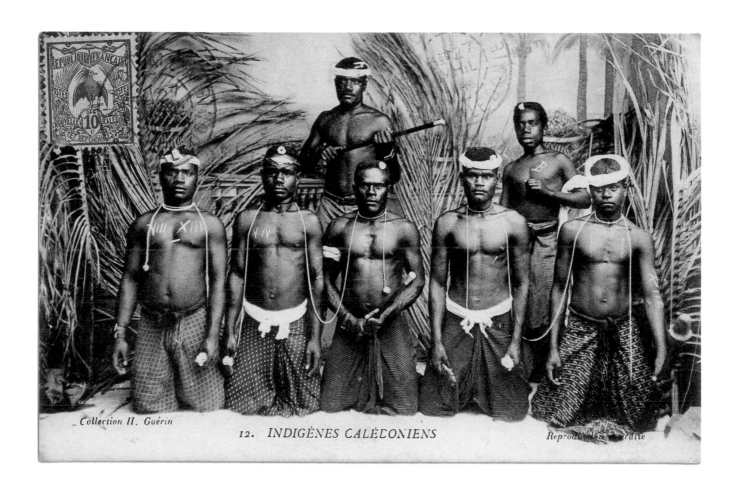

Collection H. Guérin 12. INDIGÈNES CALÉDONIENS Reproduction interdite

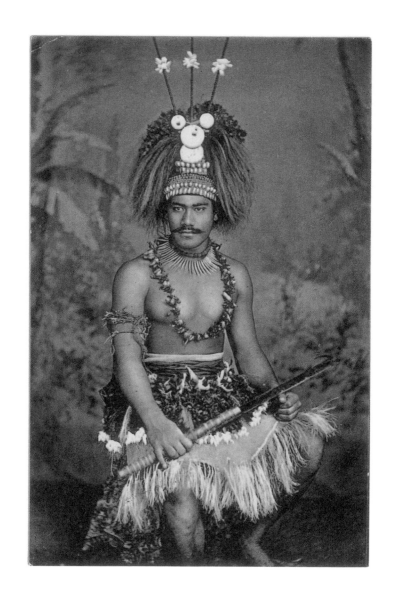

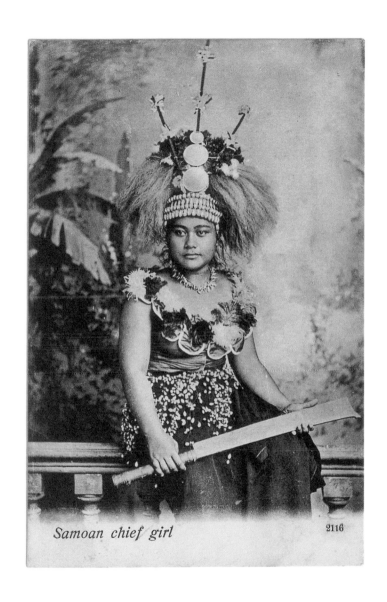

Samoan chief girl 2116

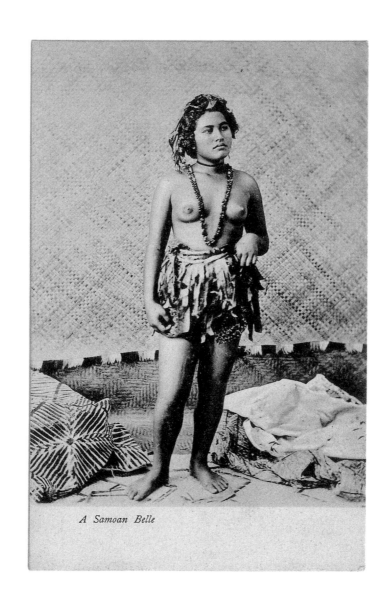

A Samoan Belle

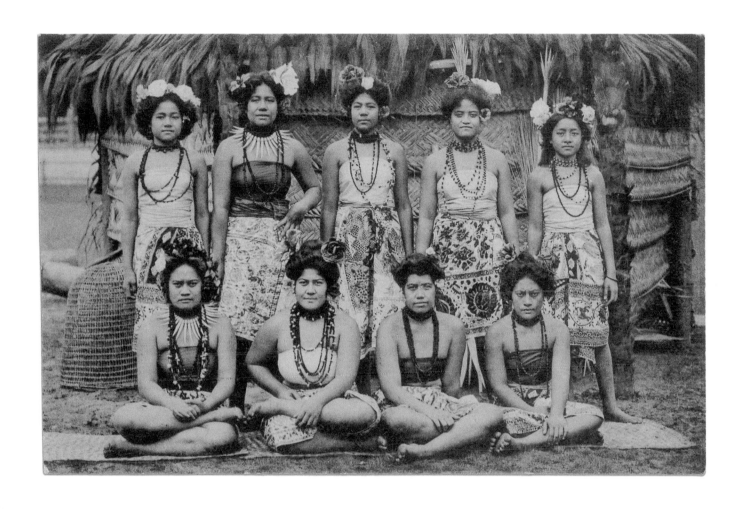

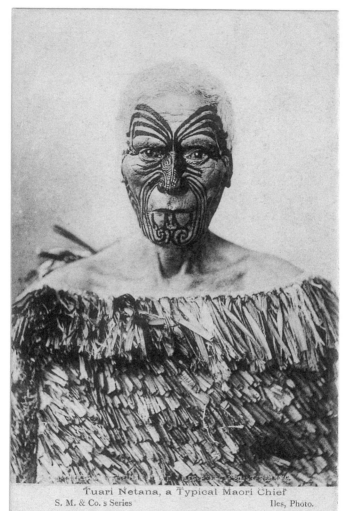

Tuari Netana, a Typical Maori Chief

S. M. & Co. s Series Iles, Photo.

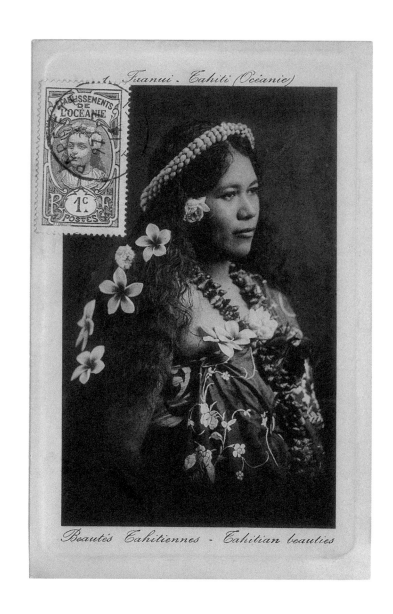

Tuanui - Tahiti (Océanie)

Beautés Tahitiennes - Tahitian beauties

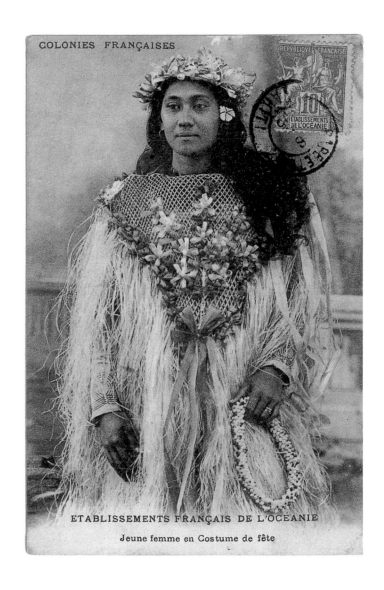

COLONIES FRANÇAISES

ETABLISSEMENTS FRANÇAIS DE L'OCÉANIE

Jeune femme en Costume de fête

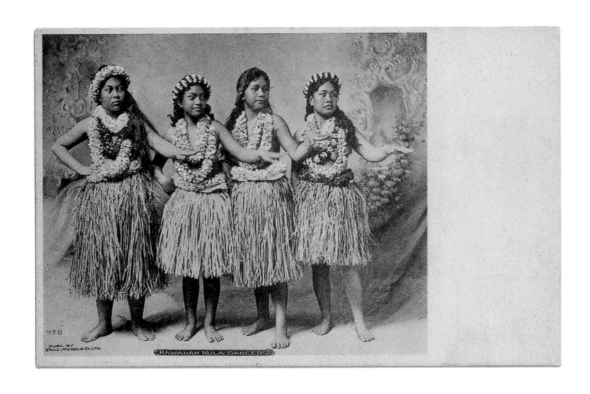

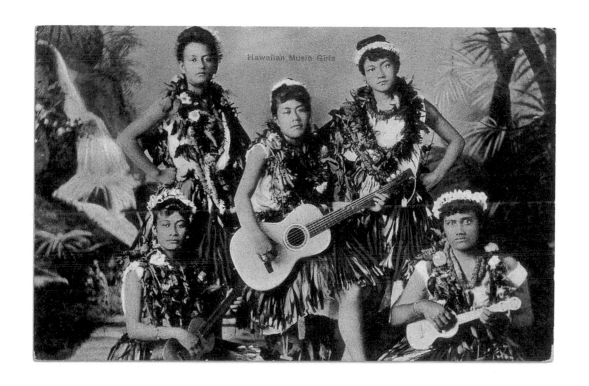

THE AMERICAS

FROM PRAIRIE TO PAMPAS

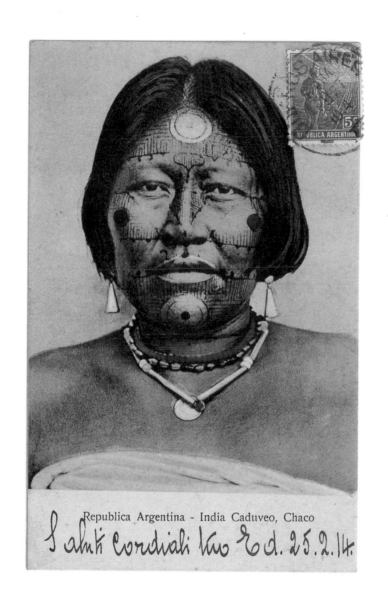

Republica Argentina - India Caduveo, Chaco

Saluti Cordiali Vro Ed. 25.2.14.

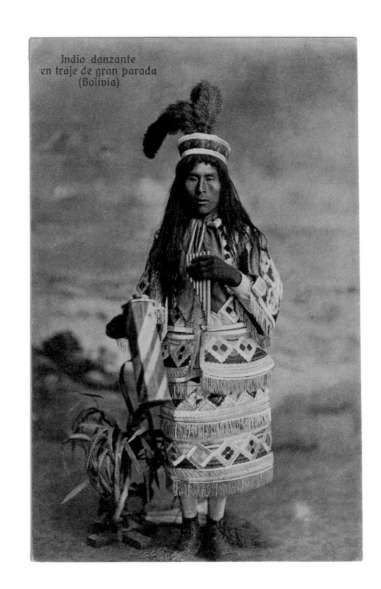

Indio danzante
en traje de gran parada
(Bolivia)

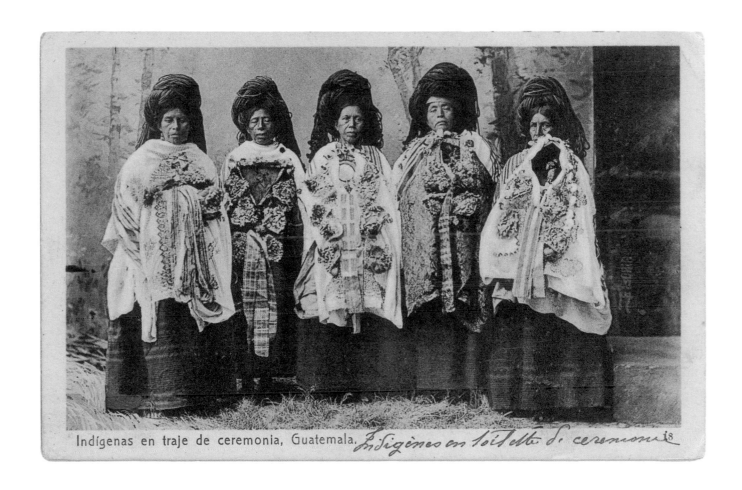

Indígenas en traje de ceremonia, Guatemala. *Indigènes en toilette de ceremonie* 18

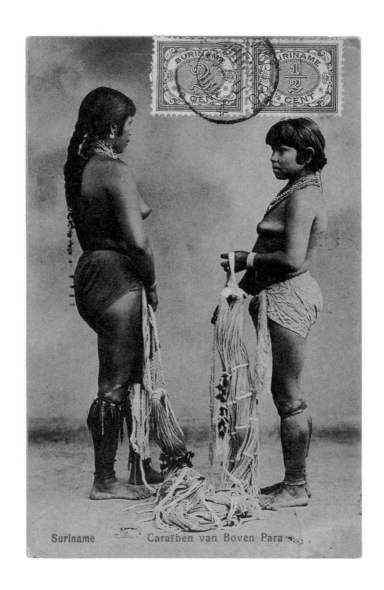

Suriname Caraïben van Boven Para

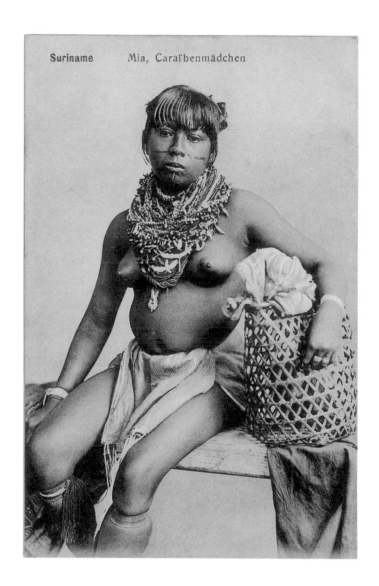

Suriname Mia, Caraïbenmädchen

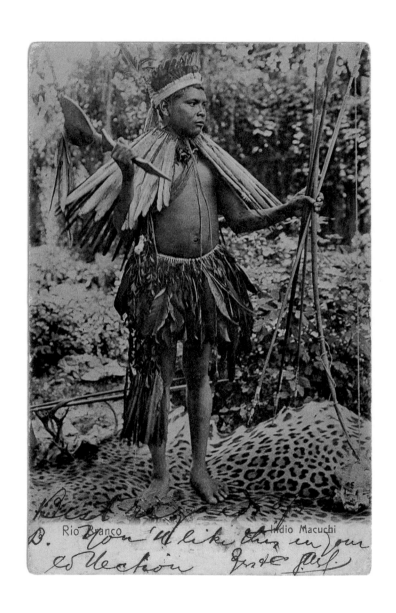

Rio Branco — Indio Macuchi

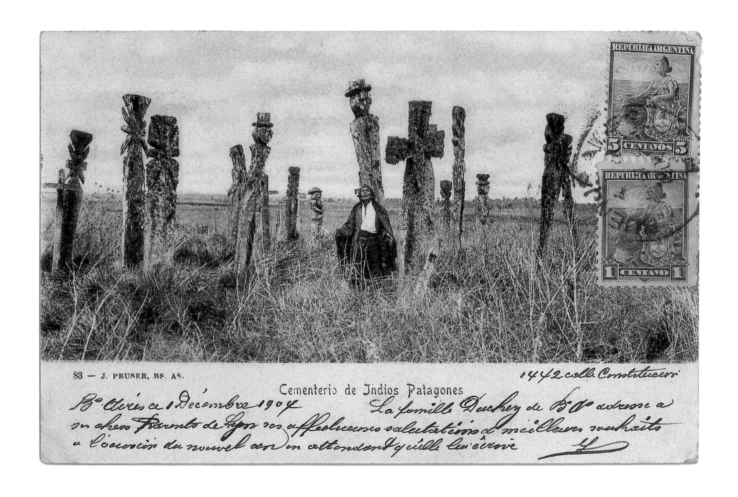

83 — J. PEUSER, BS. AS.

Cementerio de Indios Patagones

1442 calle Constitucion

Bs Aires ce 1 Decembre 1904

La famille Duchez de Bs Ve adresse a

ses chers Parents de Lyon ses affectueuses salutations et meilleurs souhaits

à l'occasion du nouvel an en attendant qu'elle leur écrive

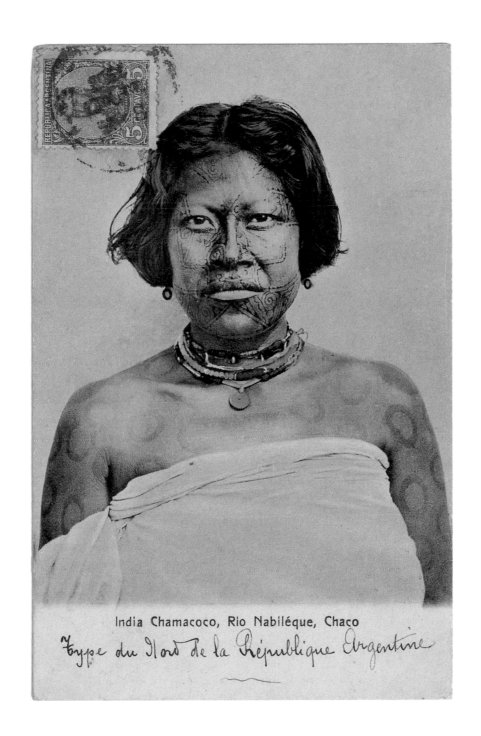

India Chamacoco, Rio Nabiléque, Chaco

Type du Nord de la République Argentine

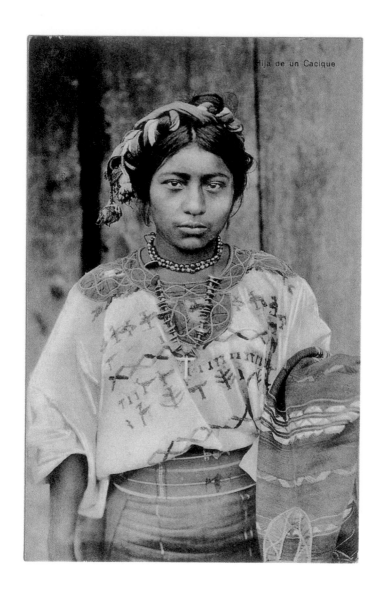

Hija de un Cacique

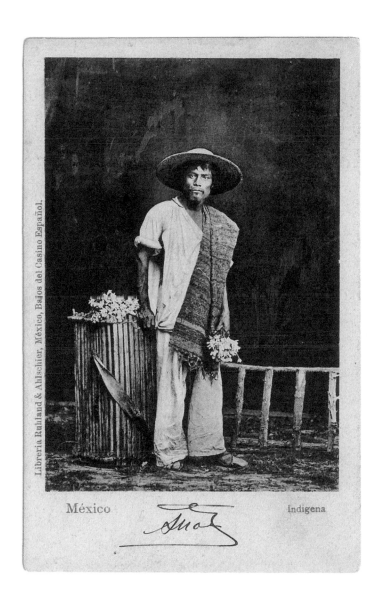

México Indígena

Librería Ruhland & Ahlschier, México, Bajos del Casino Español.

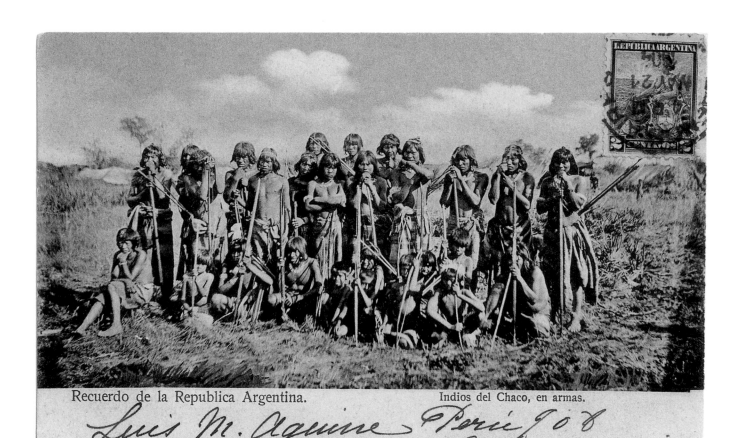

Recuerdo de la Republica Argentina.

Indios del Chaco, en armas.

Luis M. Aguirre

Perú 908

Buenos Aires

Editor: R. Rosauer, Rivadavia 522, Neg. S. F. A. de Afdos. No. 626

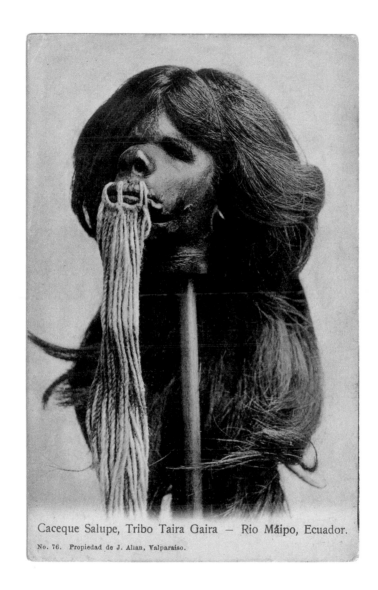

Caceque Salupe, Tribo Taira Gaira — Rio Máipo, Ecuador.

No. 76. Propiedad de J. Allan, Valparaíso.

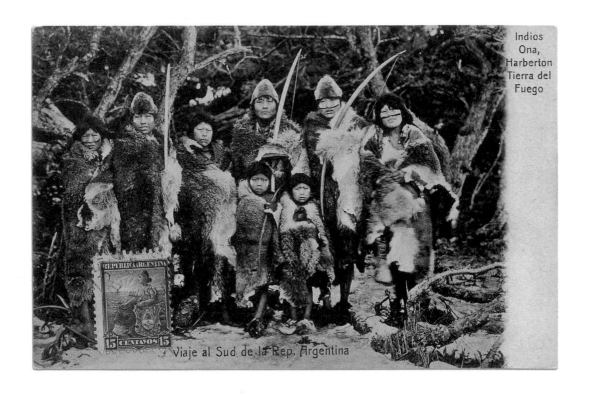

Indios Ona, Harberton Tierra del Fuego

Viaje al Sud de la Rep. Argentina

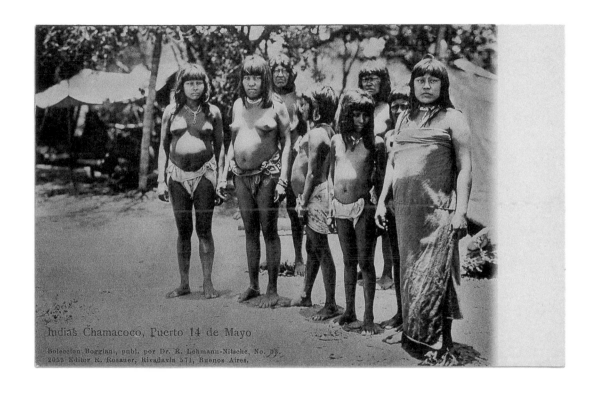

Indias Chamacoco, Puerto 14 de Mayo

Coleccion Boggiani, publ. por Dr. R. Lehmann-Nitsche, No. 95.
2053 Editor R. Rosauer, Rivadavia 571, Buenos Aires.

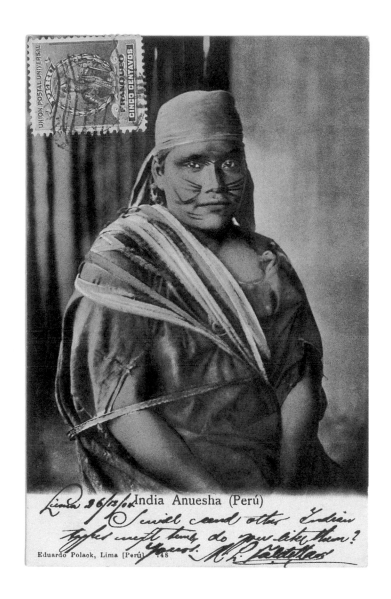

India Anuesha (Perú)

Lima 26/12/04

I will send other Indian types next time. do you like them? Yours. *[signature]*

Eduardo Polack, Lima [Perú] 148

THE ARABIC LANDS

CARAVANS ACROSS THE DESERT

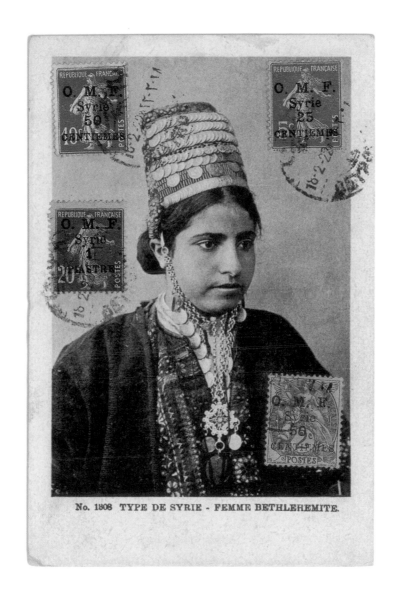

No. 1308 TYPE DE SYRIE - FEMME BETHLEHEMITE.

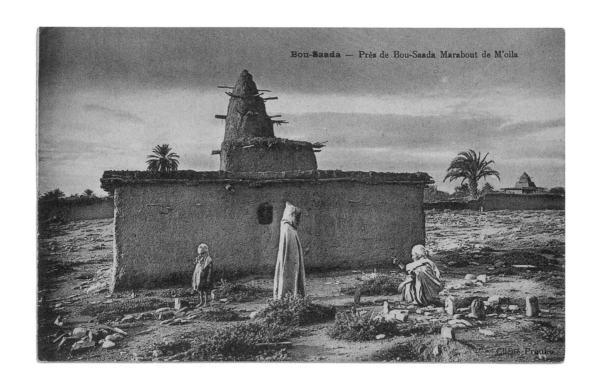

Bou-Saada — Près de Bou-Saada Marabout de M'oila

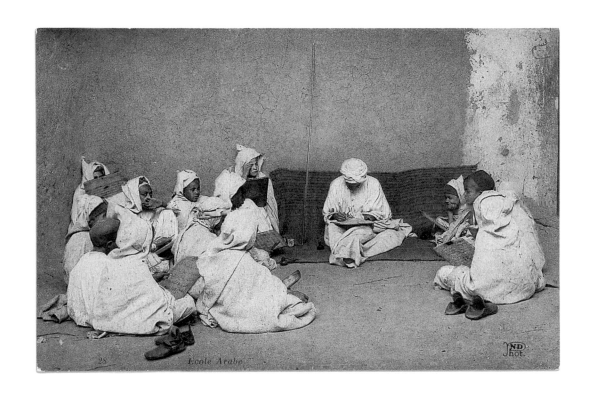

Ecole Arabe

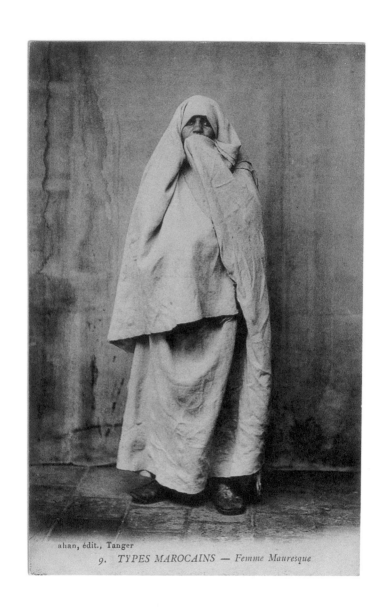

nhan, édit., Tanger

9. TYPES MAROCAINS — Femme Mauresque

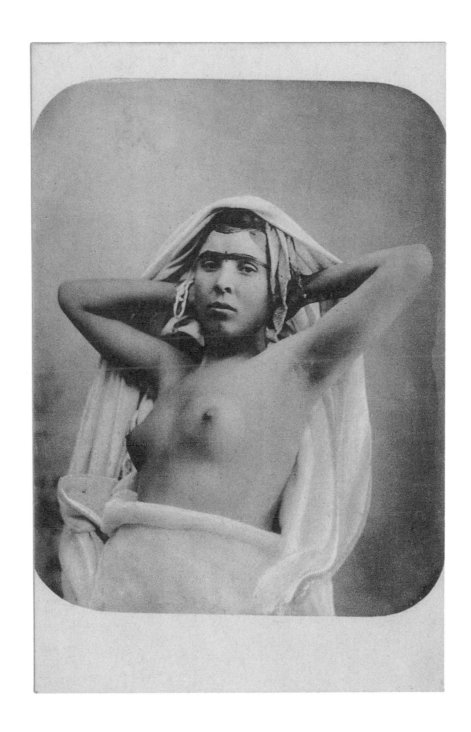

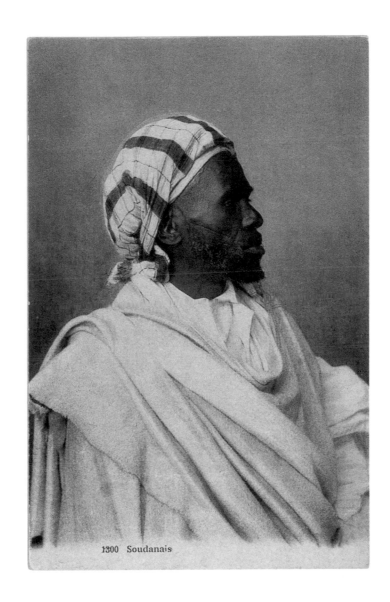

1300 Soudanais

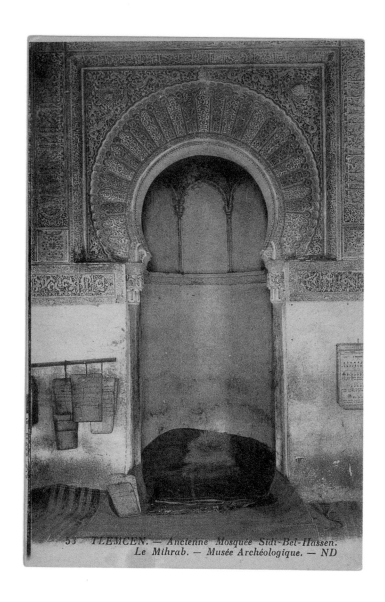

53 TLEMCEN. — Ancienne Mosquée Sidi-Bel-Hassen.
Le Mihrab. — Musée Archéologique. — ND

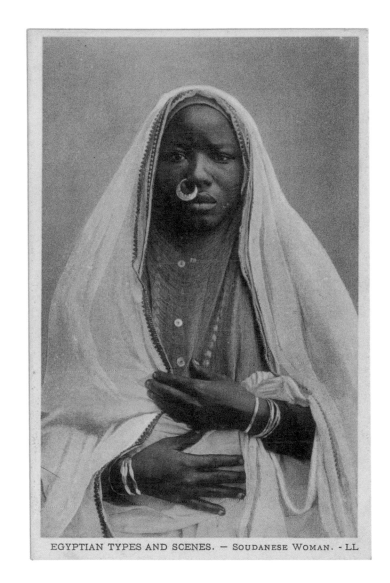

EGYPTIAN TYPES AND SCENES. — Soudanese Woman. - LL

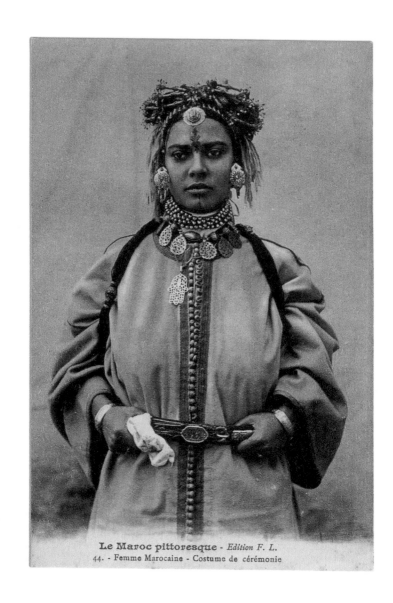

Le Maroc pittoresque - *Edition F. L.*
44. - Femme Marocaine - Costume de cérémonie

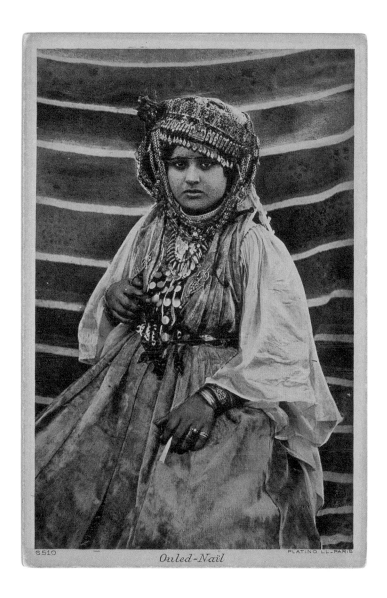

Ouled-Naïl

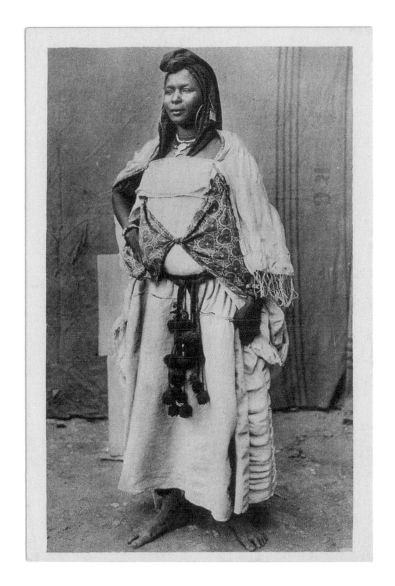

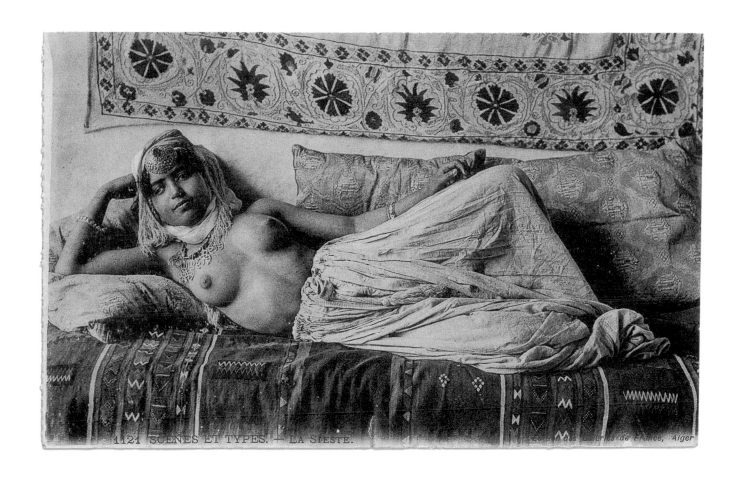

1121 SCENES ET TYPES. — LA SIESTE.

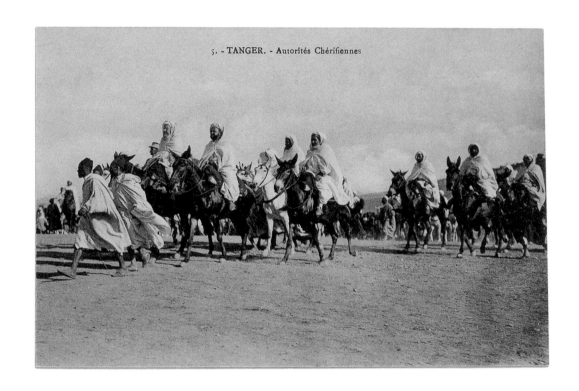

5. - TANGER. - Autorités Chérifiennes

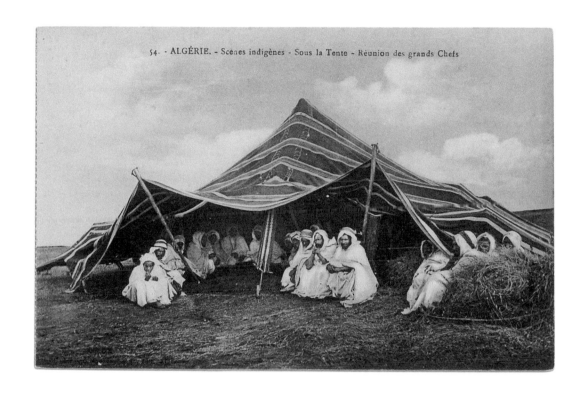

54. - ALGÉRIE. - Scènes indigènes - Sous la Tente - Réunion des grands Chefs

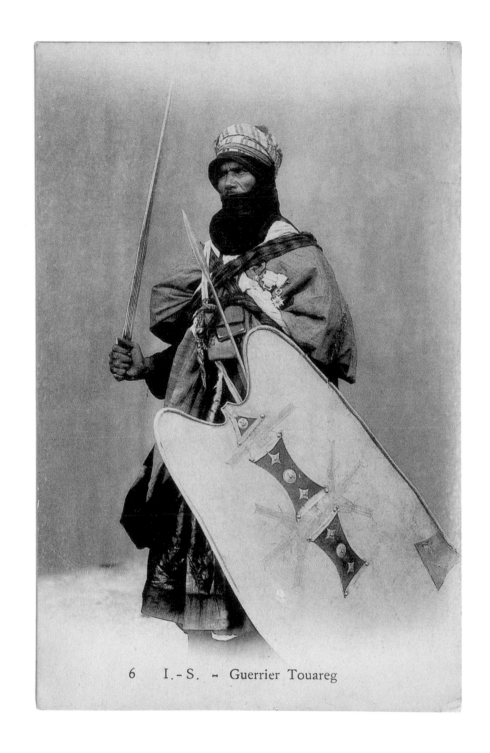

6 I.-S. ~ Guerrier Touareg

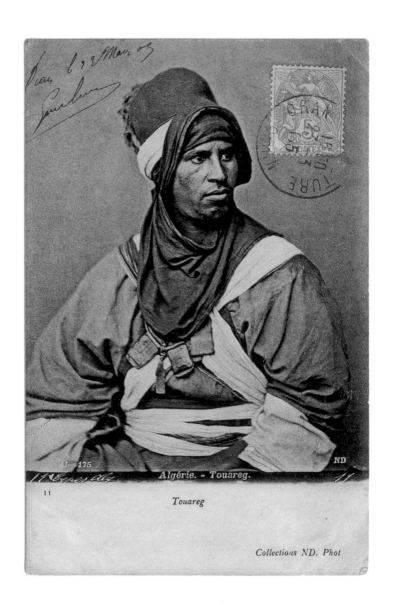

Algérie. - Touareg.

Touareg

Collections ND. Phot

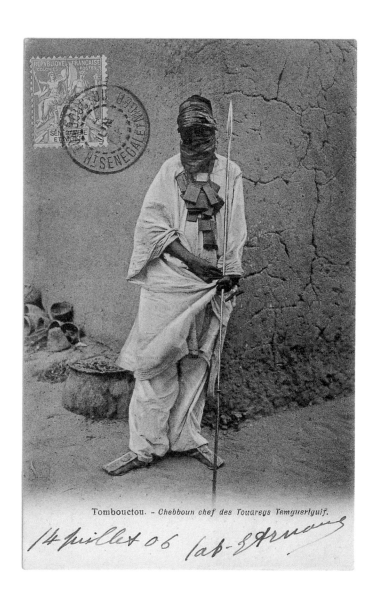

Tombouctou. - *Chebboun chef des Touaregs Tamguerlguif.*

14 juillet 06

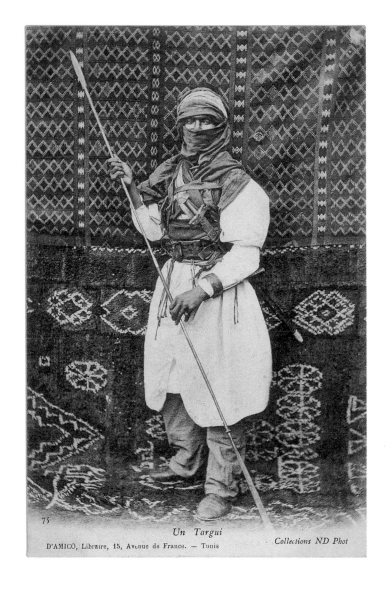

75

Un Targui

D'AMICO, Libraire, 15, Avenue de France. — Tunis

Collections ND Phot

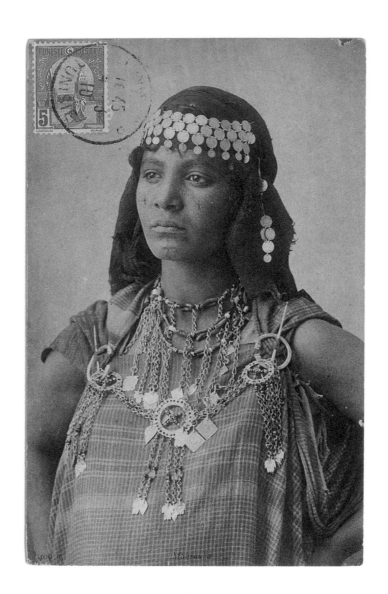

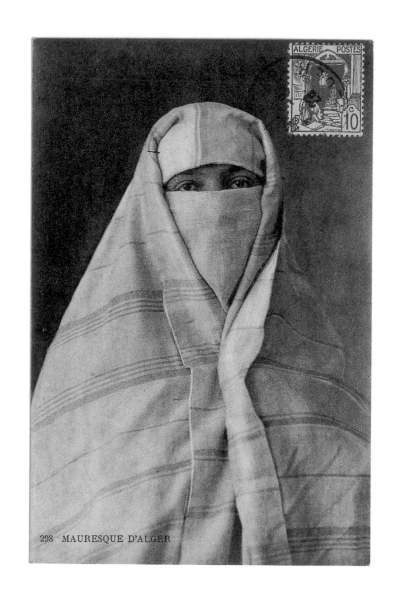

298 MAURESQUE D'ALGER

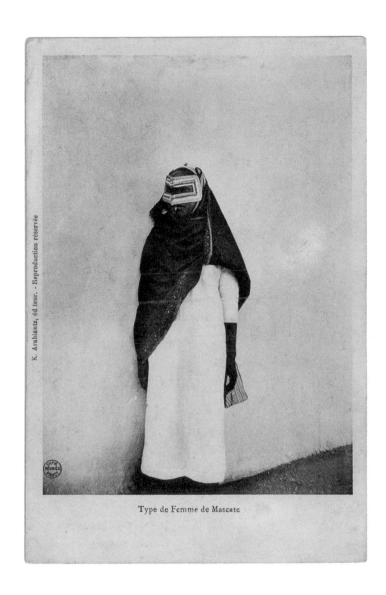

Type de Femme de Mascate

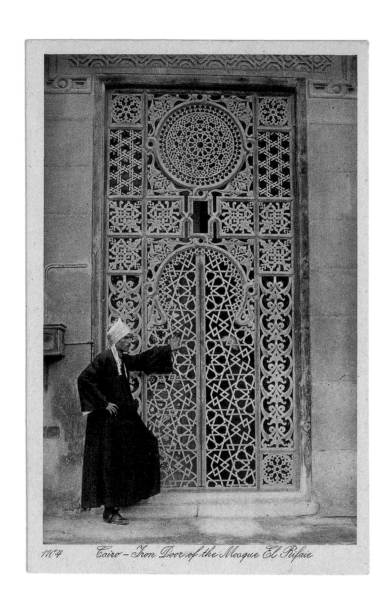

1104 Cairo – Iron Door of the Mosque El Rifaie

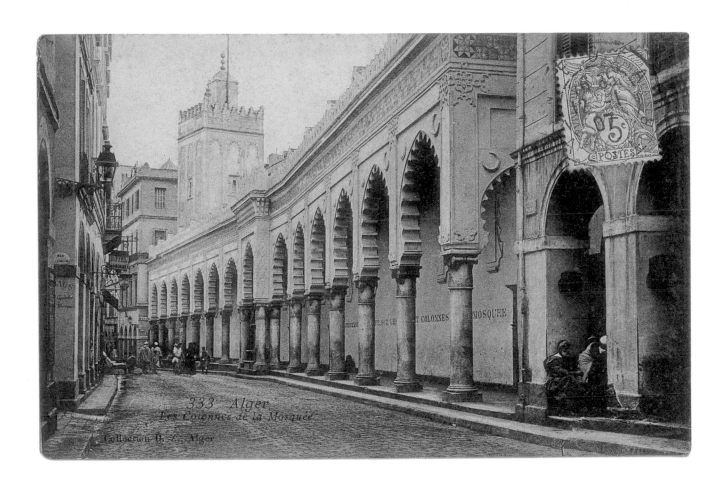

333 Alger
Les Colonnes de la Mosquée

Collection D. Z. Alger

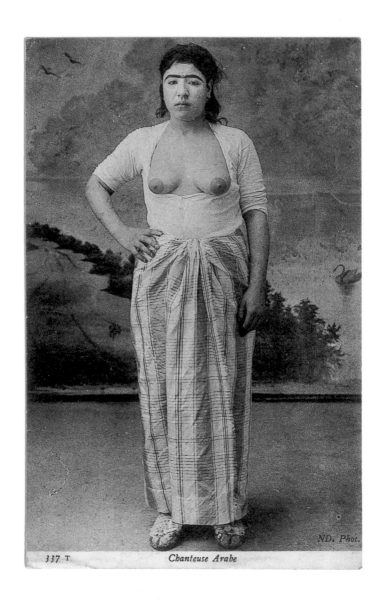

337 T *Chanteuse Arabe* ND. Phot.

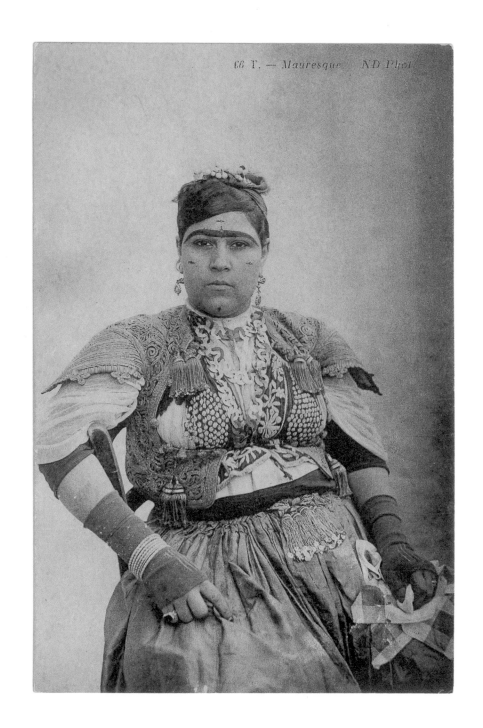

66 Y. — Mauresque. ND Phot

AFRICA

ALL THE WORLD IN ONE CONTINENT

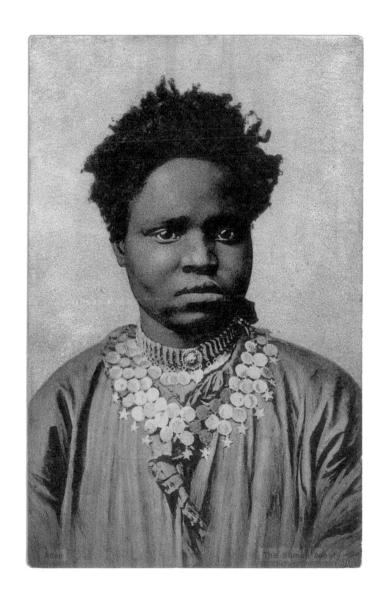

145

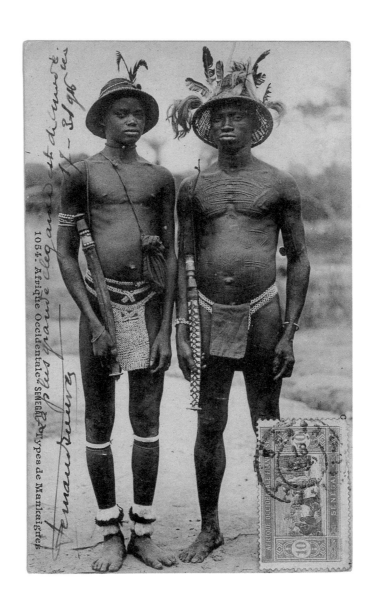

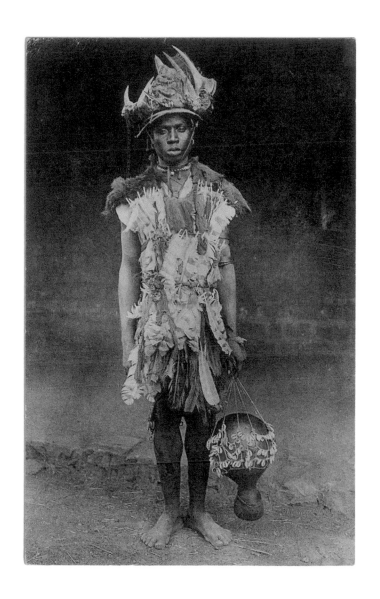

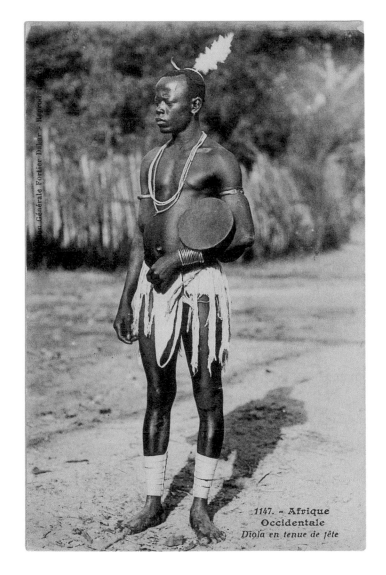

1147. – Afrique
Occidentale
Diola en tenue de fête

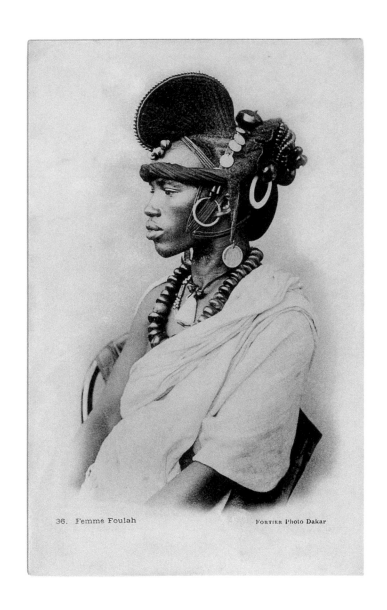

36. Femme Foulah Fortier Photo Dakar

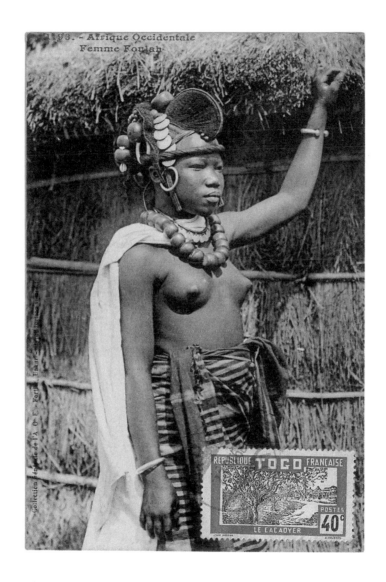

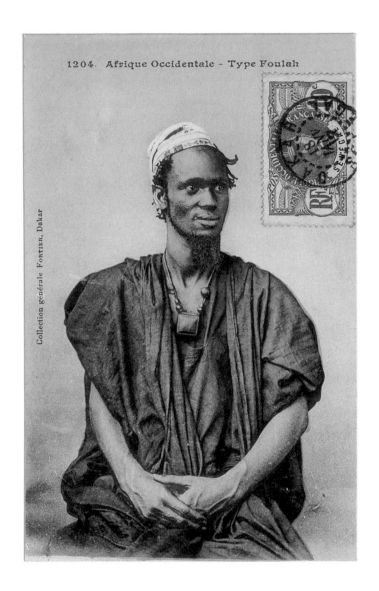

1204. Afrique Occidentale - Type Foulah

Collection générale Fortier, Dakar

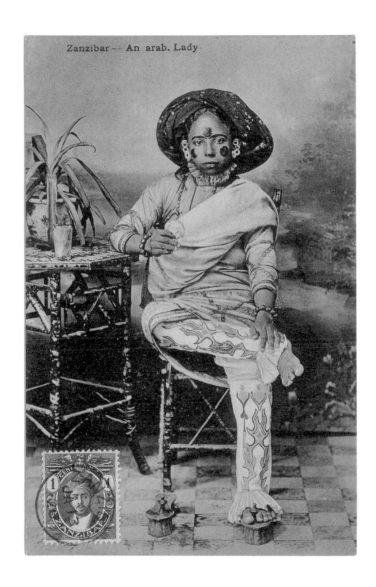

Zanzibar -- An arab. Lady.

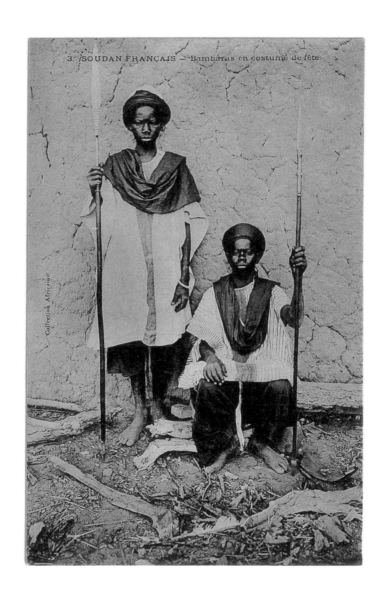

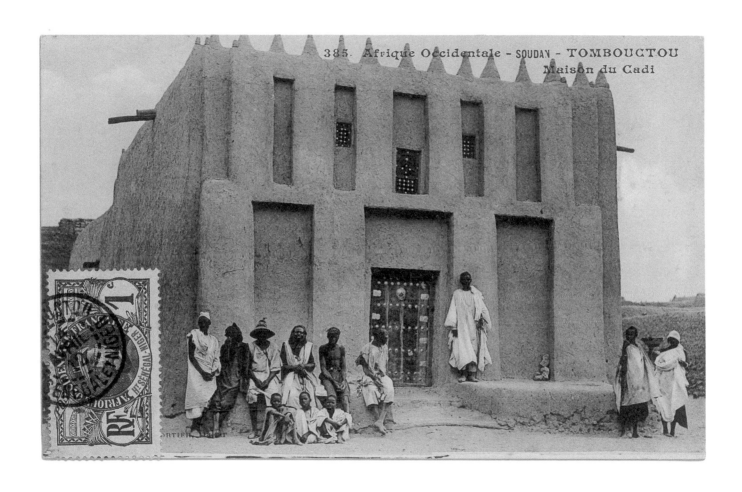

385. Afrique Occidentale - SOUDAN - TOMBOUCTOU
Maison du Cadi

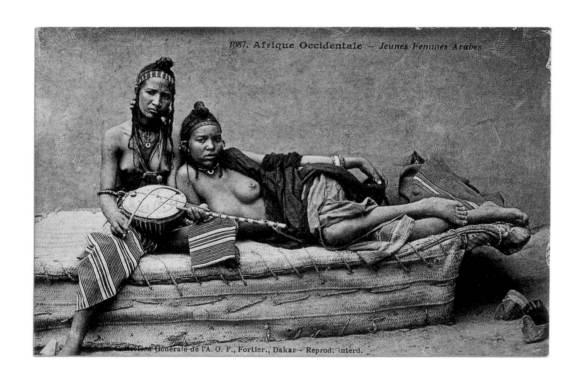

1087. Afrique Occidentale — Jeunes Femmes Arabes

Collection Générale de l'A. O. F., Fortier., Dakar - Reprod. interd.

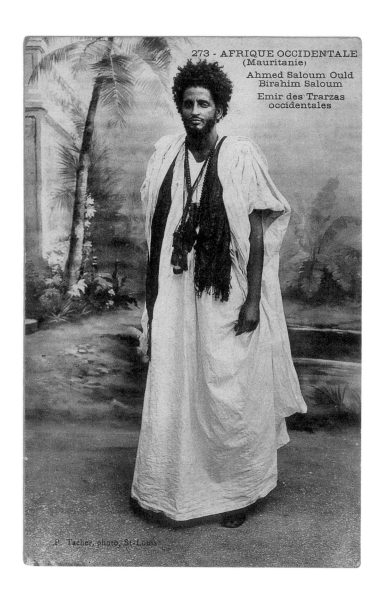

273 - AFRIQUE OCCIDENTALE
(Mauritanie)

Ahmed Saloum Ould
Birahim Saloum

Emir des Trarzas
occidentales

P. Tacher, photo, St-Louis

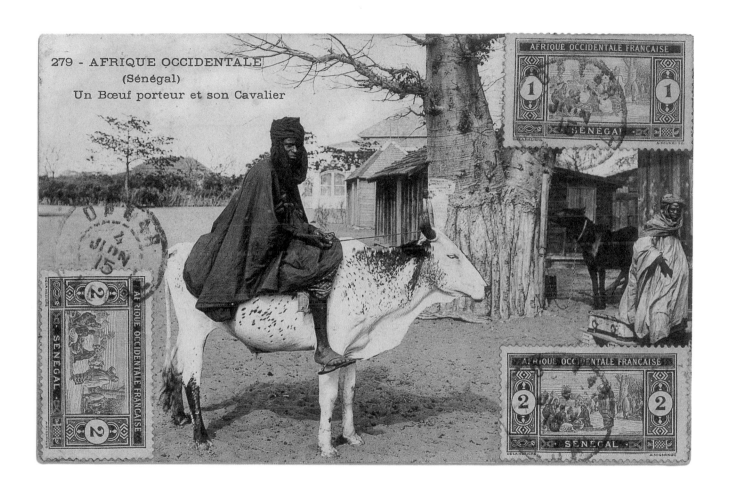

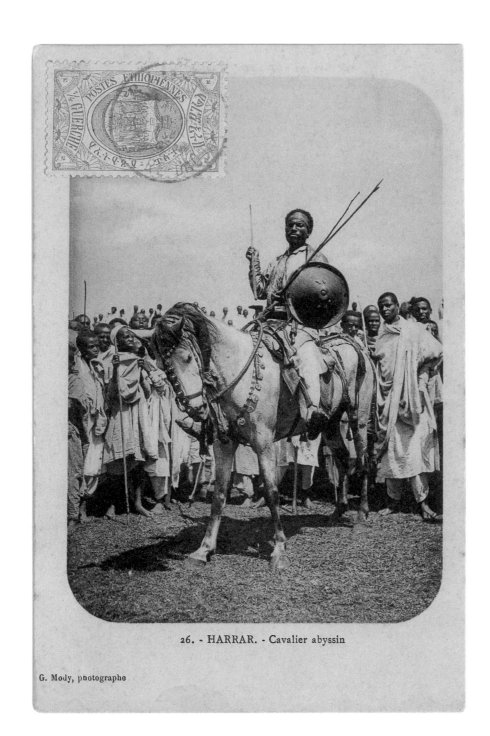

26. - HARRAR. - Cavalier abyssin

G. Mody, photographe

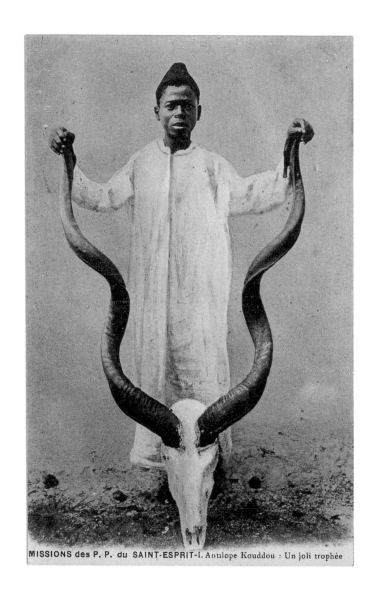

MISSIONS des P. P. du SAINT-ESPRIT-L Antilope Kouddou : Un joli trophée

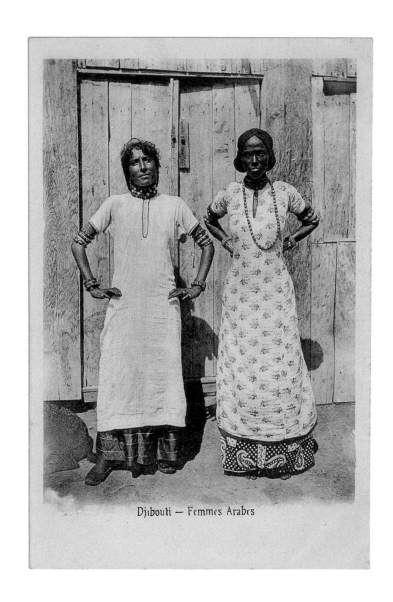

Djibouti — Femmes Arabes

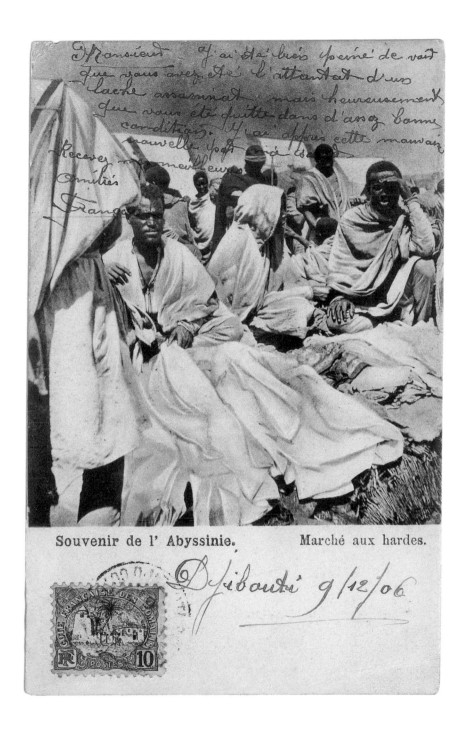

Souvenir de l' Abyssinie.　　　　Marché aux hardes.

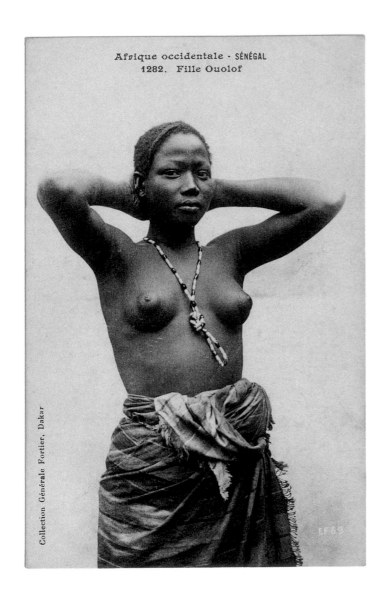

Afrique occidentale - SÉNÉGAL
1282. Fille Ouolof

Collection Générale Fortier, Dakar

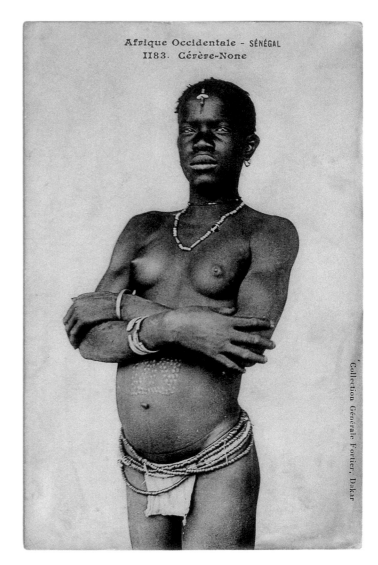

Afrique Occidentale - SÉNÉGAL
1183. Cérère-None

Collection Générale Fortier, Dakar

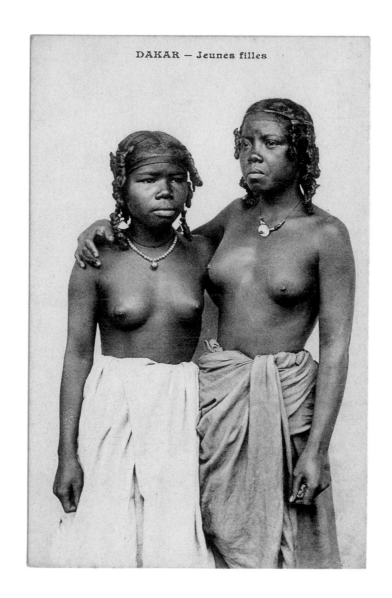

DAKAR — Jeunes filles

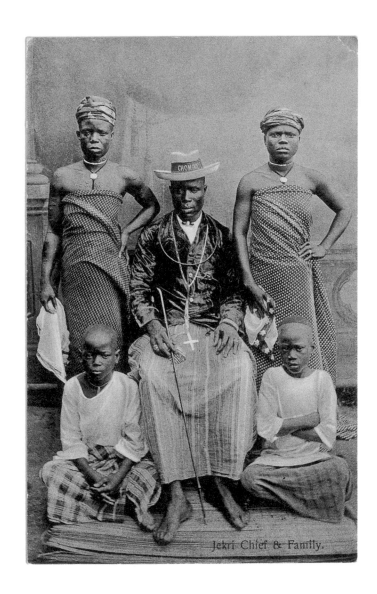

Jekri Chief & Family.

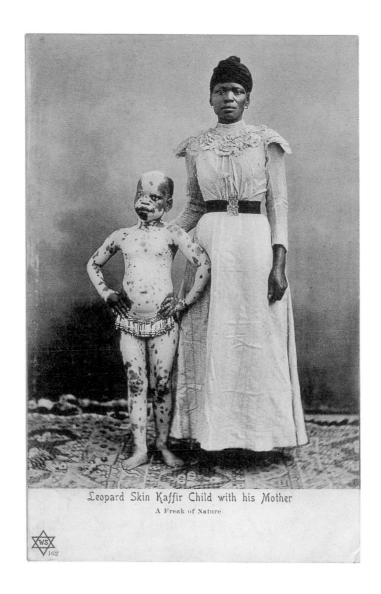

Leopard Skin Kaffir Child with his Mother
A Freak of Nature

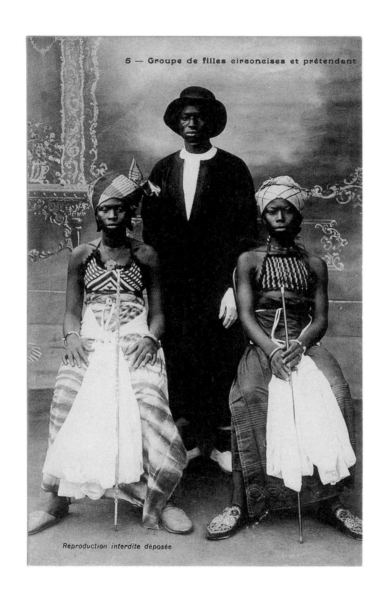

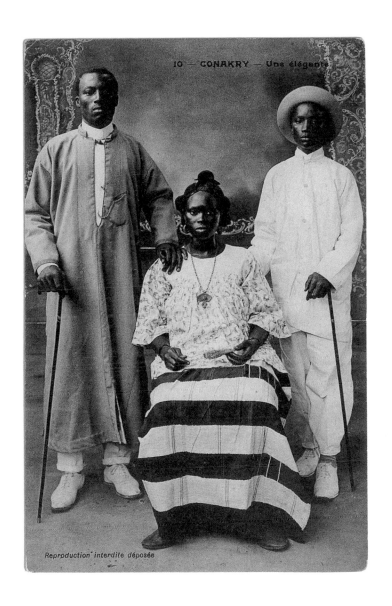

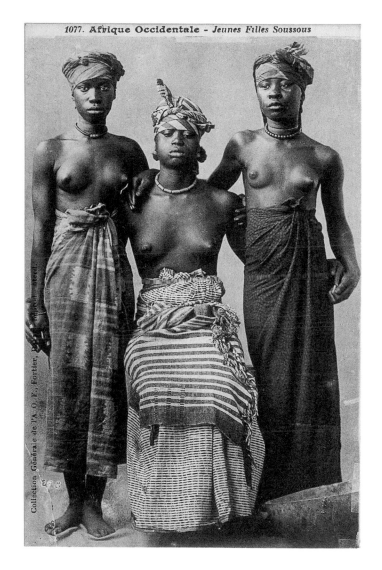

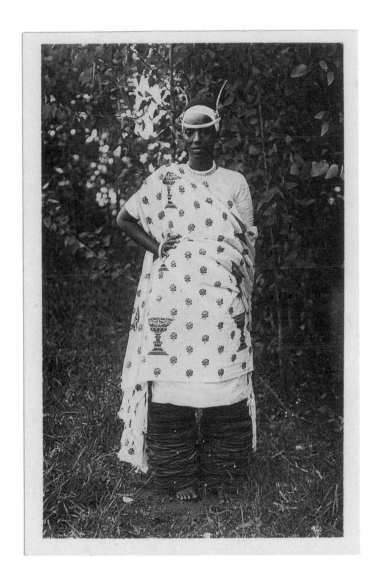

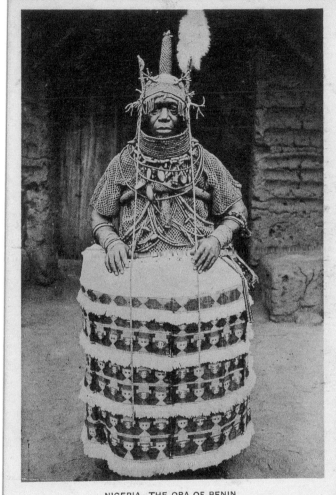

NIGERIA—THE OBA OF BENIN.

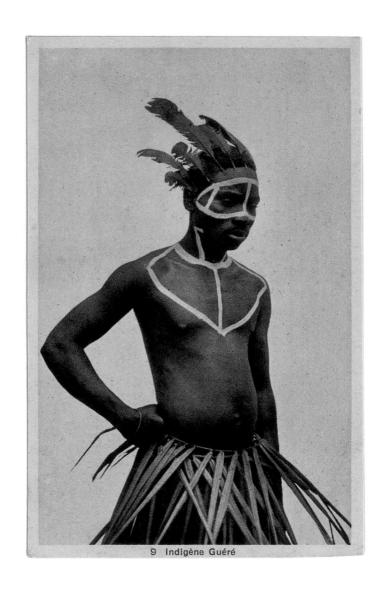

9 Indigène Guéré

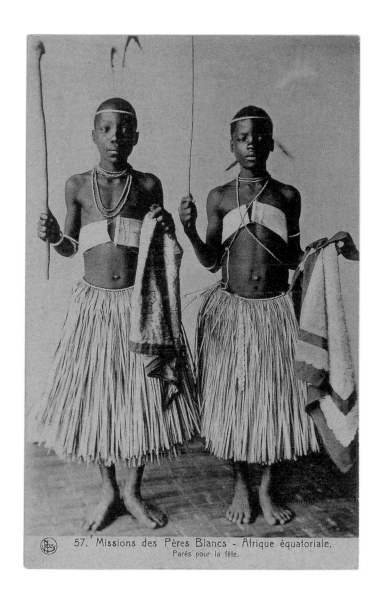

57. Missions des Pères Blancs - Afrique équatoriale.
Parés pour la fête.

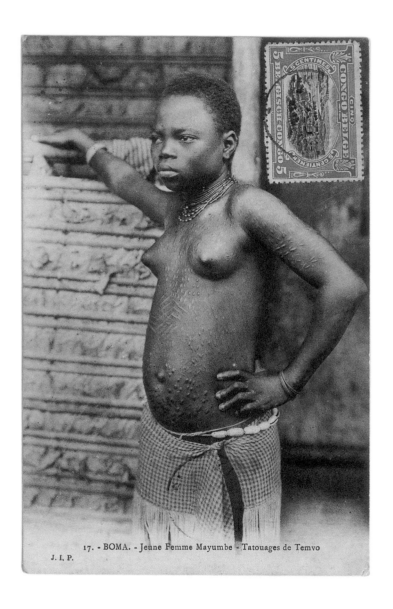

17. - BOMA. - Jeune Femme Mayumbe - Tatouages de Temvo

J. I. P.

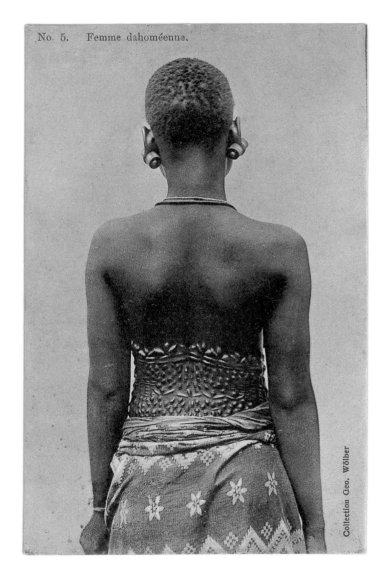

No. 5. Femme dahoméenne.

Collection Geo. Wölber

172

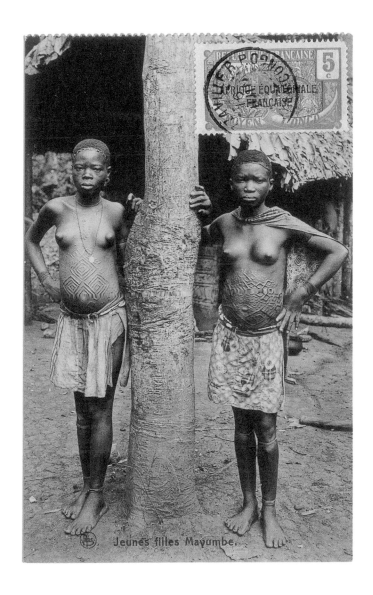

Jeunes filles Mayumbe.

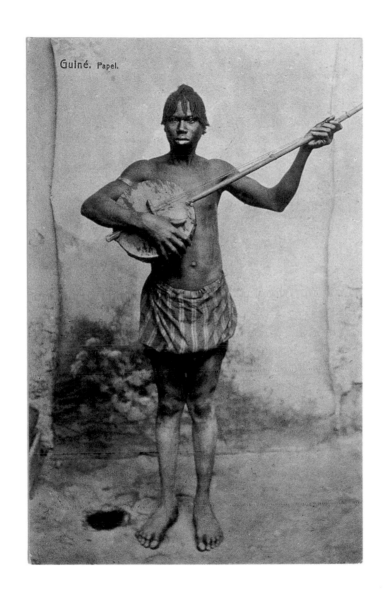

Guiné. Papel.

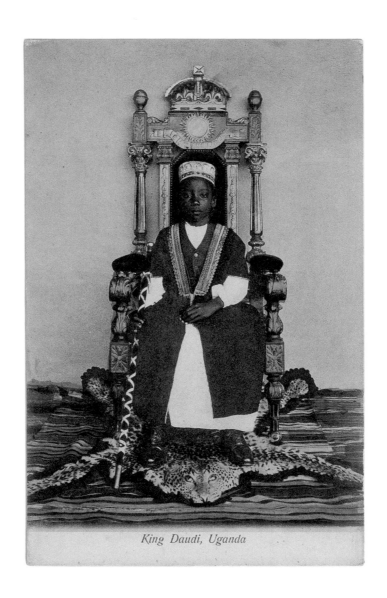

King Daudi, Uganda

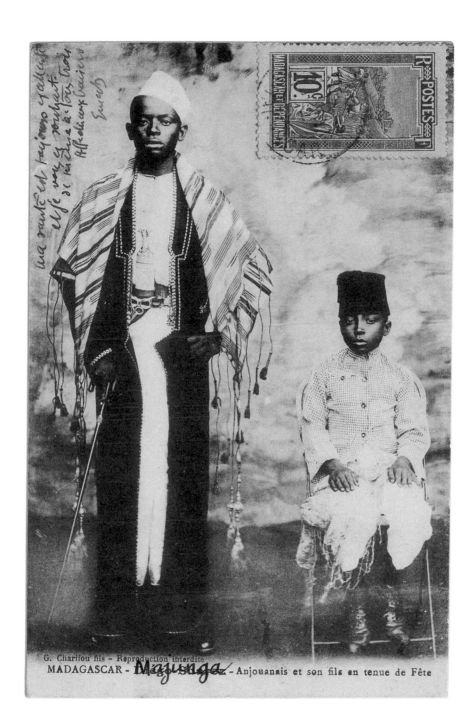

G. Charifou fils - Reproduction interdite
MADAGASCAR - Majunga - Anjouanais et son fils en tenue de Fête

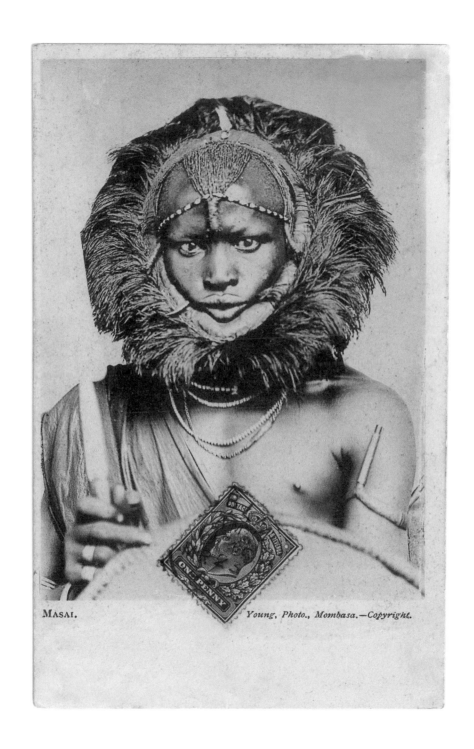

MASAI.　　　　　　　　　　Young, Photo., Mombasa.—Copyright.

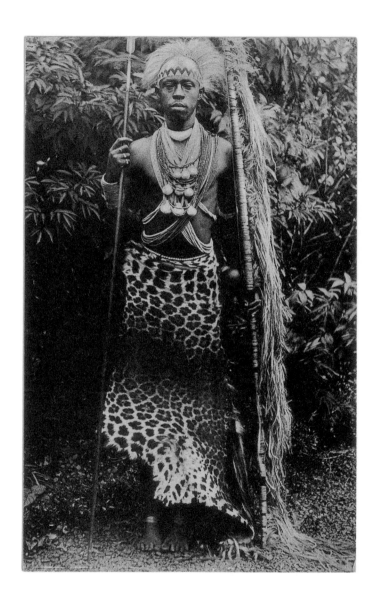

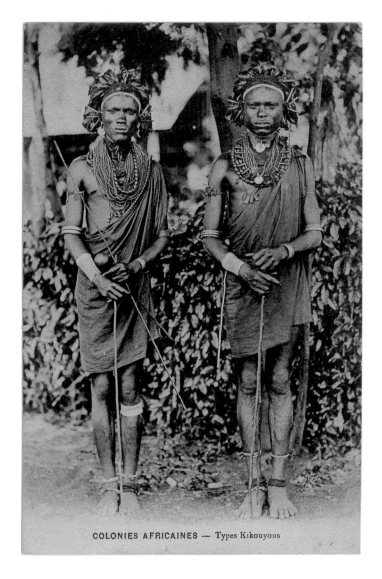

COLONIES AFRICAINES — Types Kıkouyous

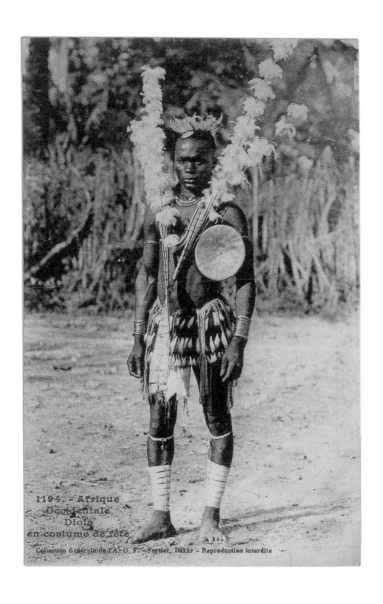

1194. - Afrique
Occidentale
Diola
en costume de fête

Collection Générale de l'A.-O. F. - Fortier, Dakar - Reproduction interdite

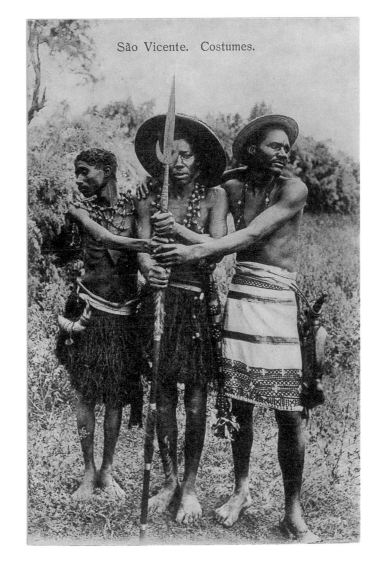

São Vicente. Costumes.

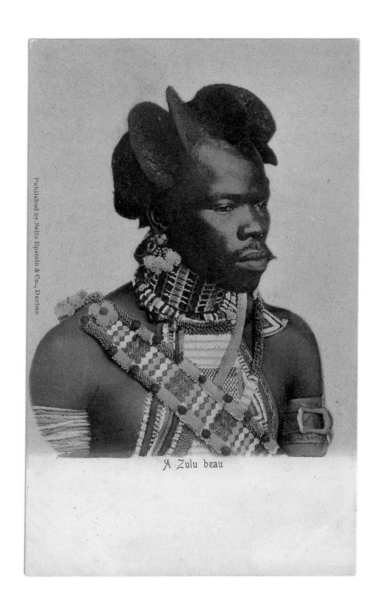

Published by Sallo Epstein & Co., Durban

A Zulu beau

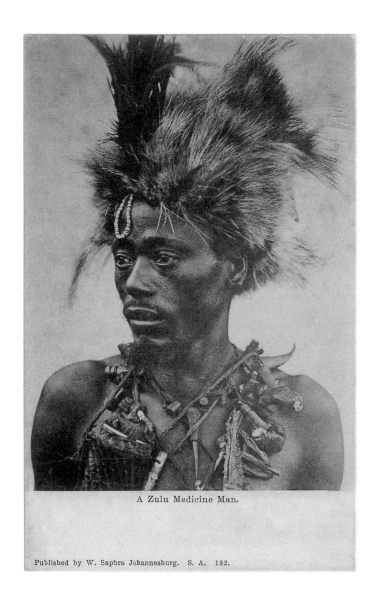

A Zulu Medicine Man.

Published by W. Saphra Johannesburg. S. A. 132.

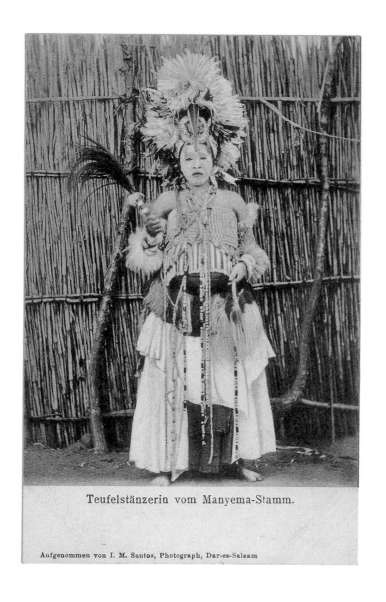

Teufelstänzerin vom Manyema-Stamm.

Aufgenommen von I. M. Santos, Photograph, Dar-es-Salaam

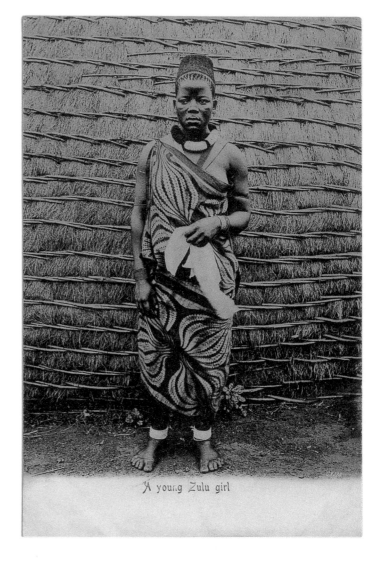

A young Zulu girl

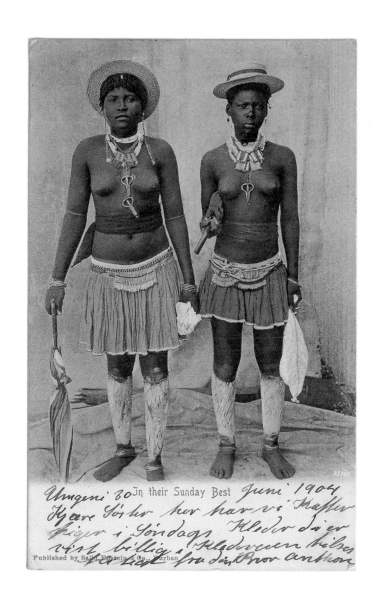

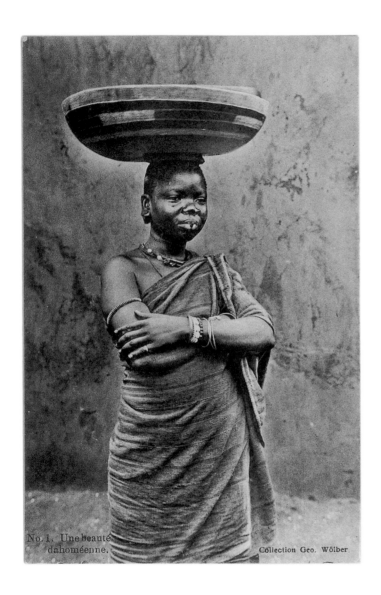

No. 1. Une beauté
dahoméenne.

Collection Geo. Wölber

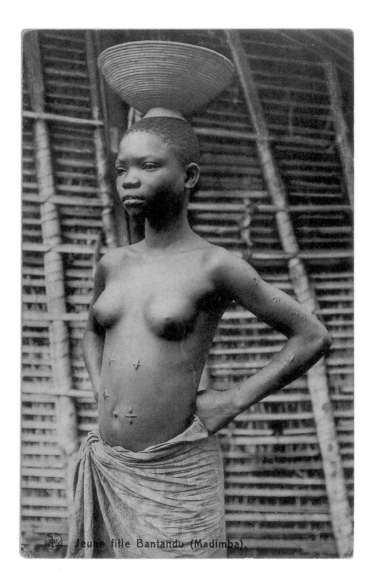

Jeune fille Bantandu (Madimba).

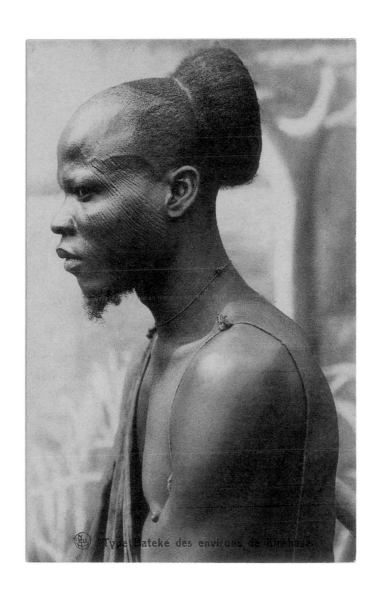

Type Bateke des environs de Kinshasa.

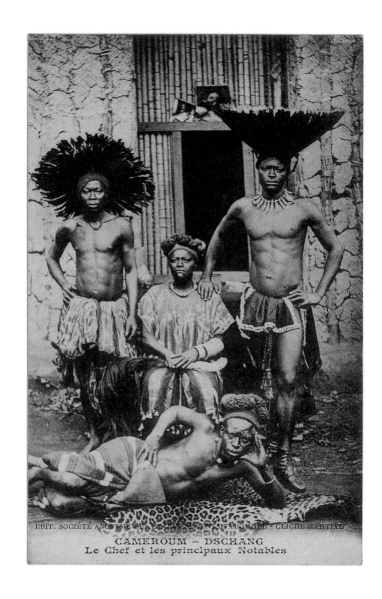

CAMEROUM — DSCHANG
Le Chef et les principaux Notables

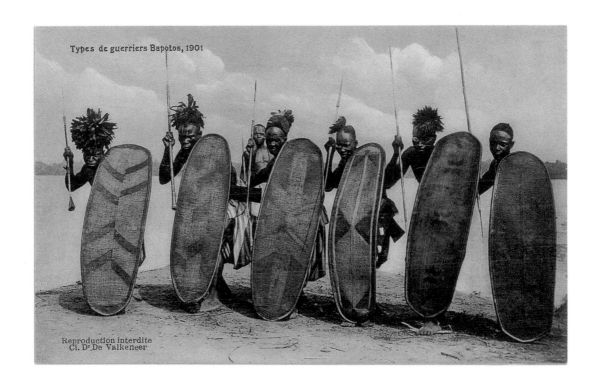

Types de guerriers Bapotos, 1901

Reproduction interdite
Cl. D.r De Valkeneer

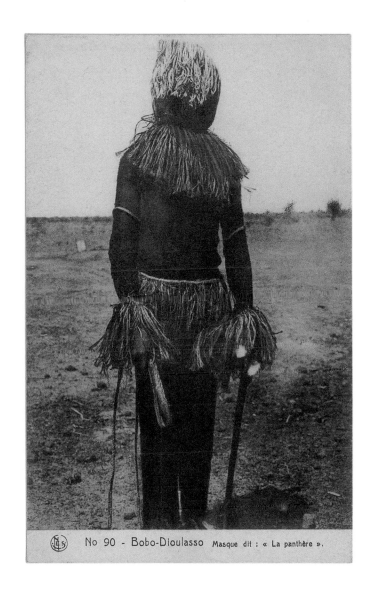

No 90 - Bobo-Dioulasso Masque dit : « La panthère ».

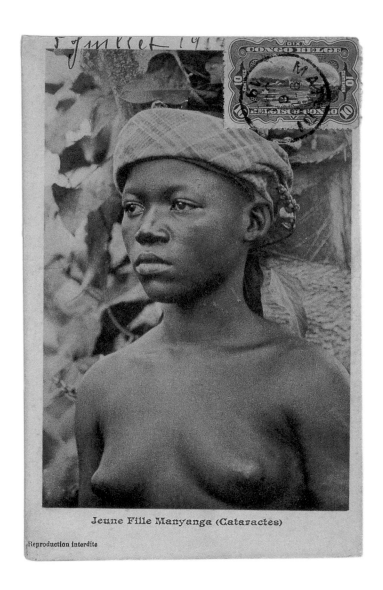

Jeune Fille Manyanga (Cataractes)

Reproduction interdite

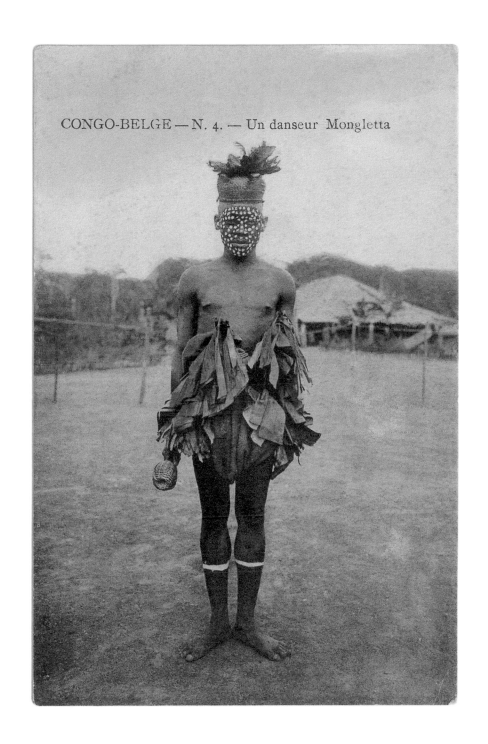

CONGO-BELGE — N. 4. — Un danseur Mongletta

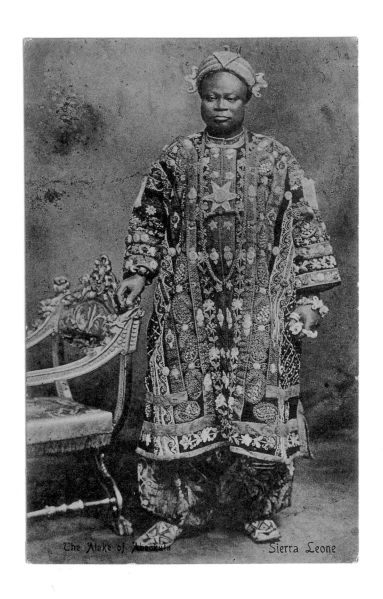

The Alake of Abeokuta Sierra Leone

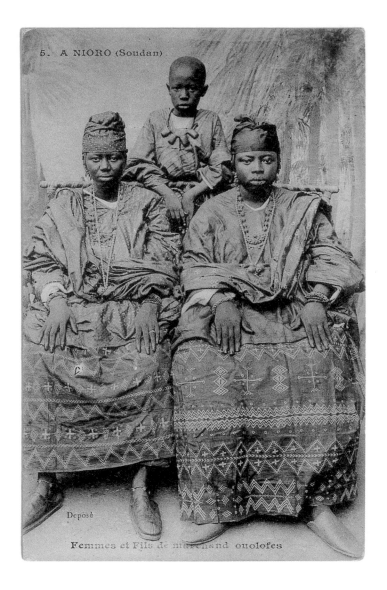

5. A NIORO (Soudan)

Deposé

Femmes et Fils de marchand ouolofes

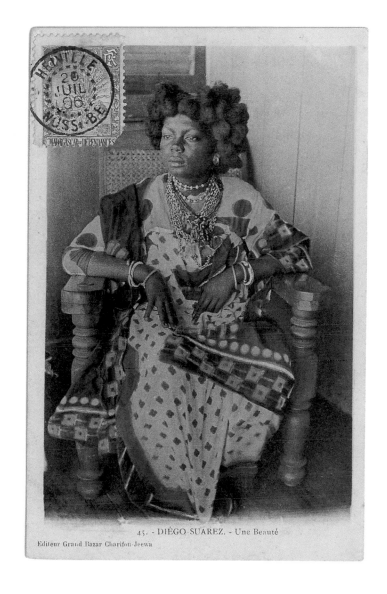

45. - DIÉGO SUAREZ. - Une Beauté

Editeur Grand Bazar Charifou-Jeewa

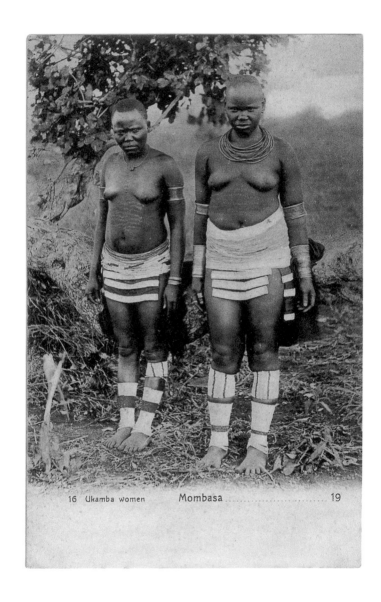

16 Ukamba women Mombasa 19

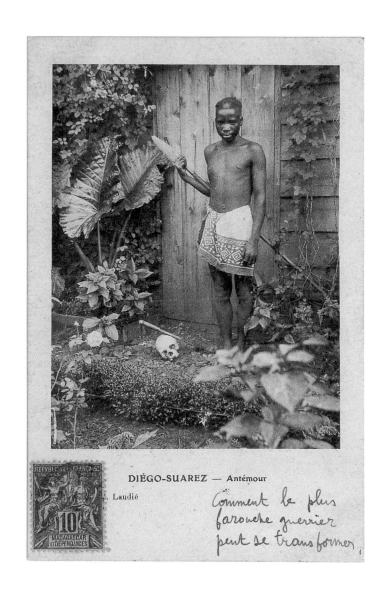

DIÉGO-SUAREZ — Antémour

Laudié

Comment le plus
farouche guerrier
peut se transformer.

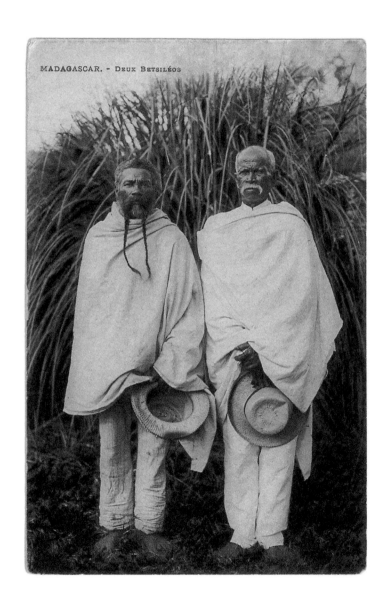

MADAGASCAR. - Deux Betsiléos

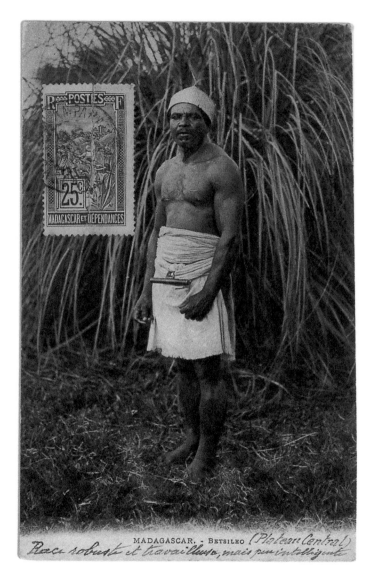

MADAGASCAR. - Betsileo (Plateau Central)
Race robuste et travailleuse, mais peu intelligente

198

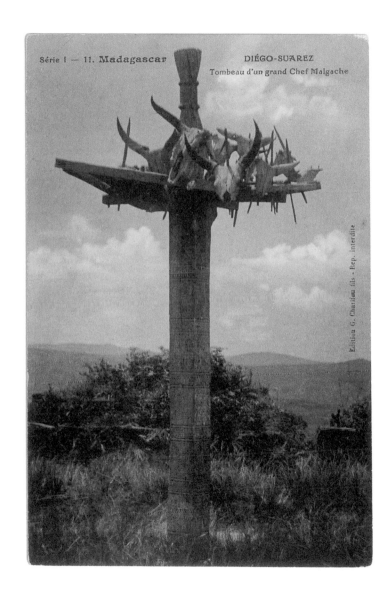

Série I — 11. **Madagascar**

DIÉGO-SUAREZ
Tombeau d'un grand Chef Malgache

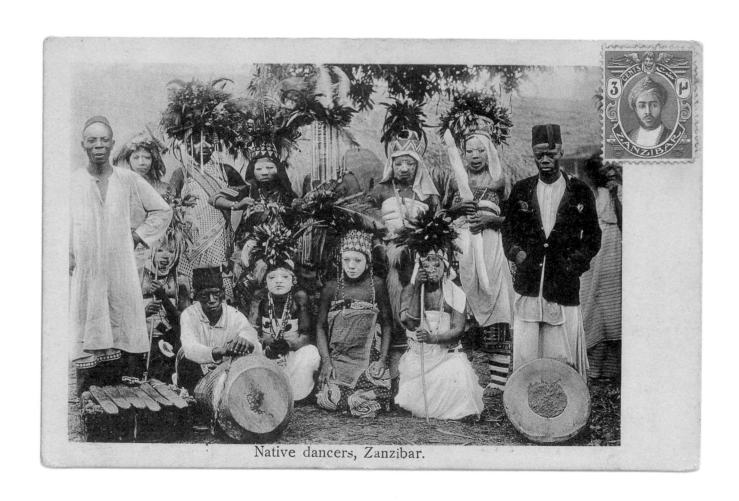

Native dancers, Zanzibar.

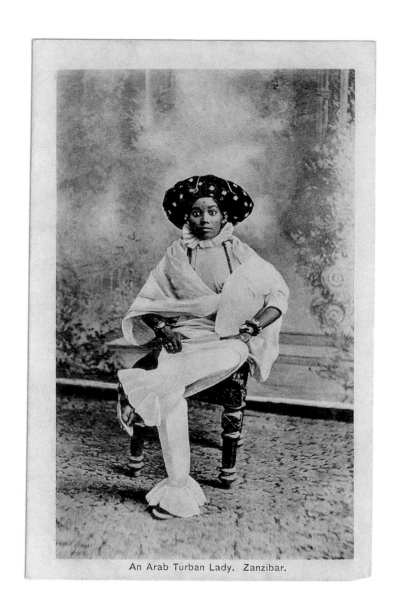

An Arab Turban Lady. Zanzibar.

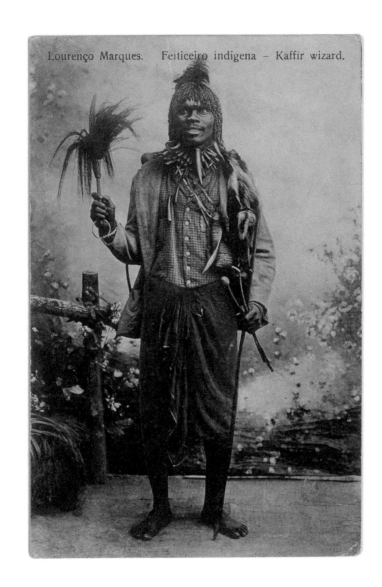

Lourenço Marques. Feiticeiro indigena – Kaffir wizard.

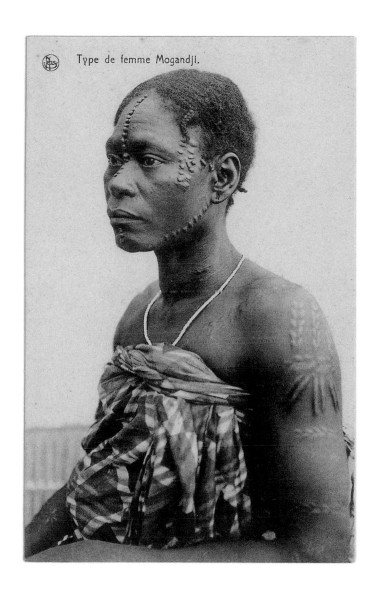

Type de femme Mogandji.

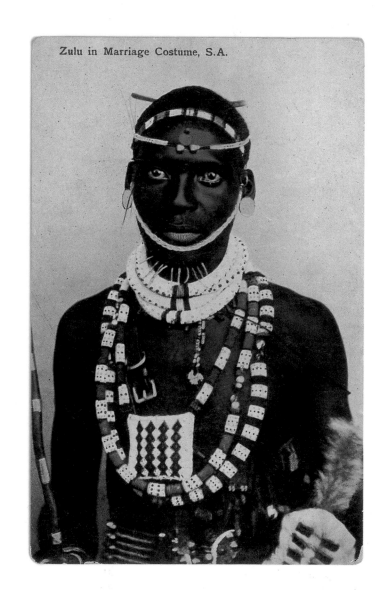

Zulu in Marriage Costume, S.A.

NOTES ON THE POSTCARDS

1 Young Somali women

2 Young Somali woman from Djibouti

3 A hut decorated with ceramics, Belgian Congo (modern-day Democratic Republic of the Congo)

4 Chinese man from Quang-Si

7 Rewi Maniapoto, Maori warrior chief, New Zealand

8 Woman in the lead role in a historical Chinese play, Saigon, Vietnam

10 Senegalese woman

11 Bangala man with scarification, Ngombe, South Africa

12 Moorish woman from Blida, Algeria

ASIA

15 Korean bride and groom

16 Men from Darjeeling, West Bengal

17 Nepalese girl from Darjeeling, West Bengal

18 Trader from Sikkim, eastern Himalayas

19 *left* Bhutia women and child, Nepal
 right Tibetan men

20 Hindu temple in Colombo, Sri Lanka

21 Hindu fakir from Sri Lanka

22 "Devil dancers", Sri Lanka

23 Indian woman

24 Indian woman

25 Sinhalese man, Sri Lanka

26 Sinhalese man, Sri Lanka

27 *left* Carved Buddhist gateway, Sanchi, India
 right Brahmin, India

28 Man from the Andaman Islands

30 Woman from the Lou-Lan region of Yunnam, Tonkin, Vietnam, 1905

31 *left* Meo hill tribe girl on the border with Yunnam, Tonkin, Vietnam
 right Meo hill tribe girls on the border with Yunnam, Laokay region, Tonkin, Vietnam

32 Borobudur Temple, Java, Indonesia

33 Monks in Phu Tho province, Cholon, Vietnam

34 Woman from South-East Asia

35 Ifugao marriage dress, Nueva Viscaya, Luzon, Philippines

37 *left and right* Haut-Tonkin woman from Vietnam

38 Siamese princess in a Tonsure costume (modern-day Thailand)

39 Ballerina from Laos

40 Vietnamese men

41 Mandarin of the "Porte de Chine", Dong Dang, Tonkin, Vietnam

42 Cambodian musician from Phnom Penh

43 Vietnamese actors

44 *left* Members of a Chinese theatrical troop, Saigon, Vietnam
 right Chinese actor

45 Young Chinese woman playing a "cythare"

46 Vietnamese actors

47 Vietnamese man from Haiphong

48 Manchurian singers

49 Young man from Vietnam

50 Rifleman from Moncay in Tonkin, Vietnam

51 Woman from Laos

52 Ming tombs, Peking, China

53 left Man from Tonkin, Vietnam

53 right A South-East Asian prison

54 Vietnamese mechanics, Saigon

55 Vietnamese men from Haiphong

56 Members of the Chinese garrison playing trumpets in Yunnan, China

57 In a restaurant, Saigon, Vietnam

59 Dyak chief, Singapore

60 Dyaks from Borneo

61 *left* No information given
 right Dyak warriors, Borneo

62 Head hunter's home, Luzon, Philippines

63 Working in the paddy fields

64 Women from Saigon, Vietnam

65 Members of the Cho-Ma tribe, Haut Donai, Vietnam

67 Indonesian men from Jakarta

68 No information given

69 Annamite woman, Saigon, Vietnam

70 Corn field in Tonkin, Vietnam

71 Religious festival in Osan, South Korea

73 Chinese beauties from Manchuria

74 Japanese woman

75 Stone carving above a doorway in Nikko, Japan

OCEANIA

77 Samoan girls preparing kawa

78 Maori chief, Hoera Watene, New Zealand

79 Fiji chief in his official dress

80 Aboriginal chief

81 Aboriginal with "devil's mask"

82 Man from Koumac, New Caledonia

83 *left* Couple from New Caledonia
 right Naudaï man from Adio, New Caledonia

84 War mask from Kouaoua, New Caledonia

85 Mekeo dancers, Papua New Guinea

87 Men from New Caledonia

88 Samoan man

89 Samoan chief girl

90 Samoan woman

91 Samoan women

92 Tuari Netana, a Maori chief

94 Tahitian woman

95 Polynesian woman in festival costume

96 Hawaiian Hula dancers

97 Hawaiian "music girls"

THE AMERICAS

99 Caduveo Native American woman, Chaco, Argentina

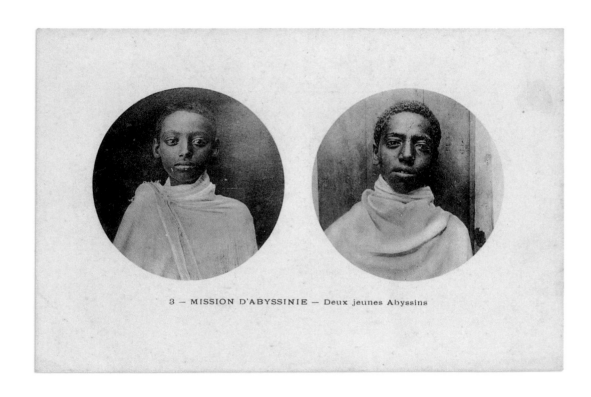

3 — MISSION D'ABYSSINIE — Deux jeunes Abyssins